Guide

TO STREET ART

STÉPHANIE
LOMBARD

IN *Paris*

L | LANNOO

4

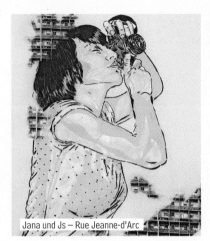

Jana und Js – Rue Jeanne-d'Arc

THE AUTHOR

Stéphanie Lombard writes the wonderbrunette.com blog and loves meeting street artists for interviews and photos of them in action. She roams Paris and its working-class suburbs, France's big cities and the metropolises of the world in search of the big names in urban art and the street artists to follow.
www.wonderbrunette.com

A WORD OF THANKS

Thank you Pierre B.,– it's because of you that I was able to complete this great shared project.
Thank you Pierre-Olivier for your hands-off support.
Thanks to my friends and my family, especially Matias, Moune & Farid.
To the people who read my blog (wonderbrunette.com) and always give me so much energy.
Thanks to the artists for the wonderful surprises they spring on you when you turn the corner of the street: without them, life would not be so colourful (in my eyes).
Stéphanie Lombard

FOREWORD

As a major fan of graffiti, street art and photography, I have kept a blog for the past few years on urban art in Paris and beyond.

When the first edition of this guide appeared in 2017 in French, that was an enriching experience that brought contacts with enthusiastic readers and booksellers. I have equally enjoyed updating and further developing the Guide to Street Art in Paris. In this 2020/21 edition, I have added new routes, interviews and new photos that let you explore or rediscover the French capital and its suburbs via its street art.

People often see street art as something ephemeral. Which is true… up to a point. In recent years, a creative relationship has developed between the city and urban art in the form of links and exchanges, often enlightening the lives of local residents.

Urban culture has been given more space thanks to the cooperative efforts of municipalities, galleries and associations that recruit artists, so that it is finally finding sites where it can express itself. Urban art has now become a lasting phenomenon in the city.

Monumental murals, encounters between artists and locals, districts where creative expressions are constantly being renewed, dedicated walls and so on. Although certain artworks inevitably get painted over by others (which will undoubtedly be the case for some works presented in this guide), the street art scene is still here to stay in Paris.

Happy walking — and keep your eyes open!

Stéphanie Lombard

GUIDE
HOW TO USE IT

This guide has ten routes that let you explore Paris and its suburbs. Each route consists of:

↘ a map with the route drawn in, also showing the sites and recommended addresses

↘ a signposted route called **Follow the guide** that takes you on a voyage of discovery of a neighbourhood through its urban art

↘ sections telling you more about the artists or the places you will see on the route

↘ boxed sections called **Don't miss!**, **In conversation** and **Artist in the spotlight** to let you take stock of the must-see artworks, places and artists

↘ a **Good to know** section with practical info on events linked to street art or urban culture places

↘ a **list of addresses** for bars, restaurants, galleries, bookshops, etc.

↘ a **Zoom in** section telling you more about associations, urban art expressions, the various techniques used and so on

↘ a **wall** at the end of the route, a double-page spread of photos showing the mood of the neighbourhood.

MAP LEGEND
▶ route start
▬▬▬ route you follow
❶ street art you can see on the route
① recommended address

CONTENTS

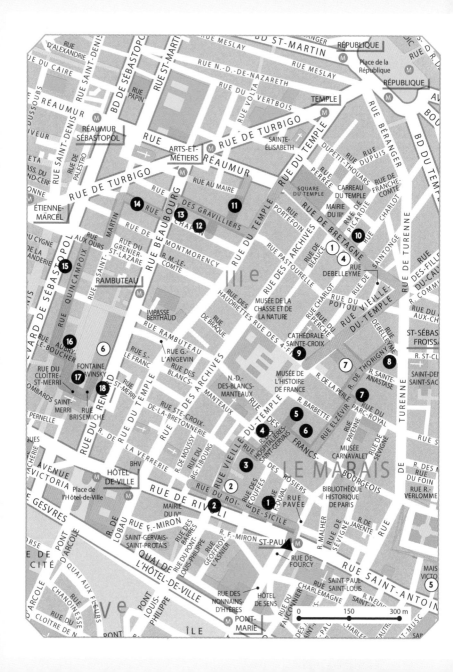

In the heart of **THE MARAIS**

A two-hour stroll through the streets of the Marais, from Rue de Rivoli to Place Igor-Stravinsky. Sound good? The neighbourhood chosen by Konny and Invader, whose mosaics pay homage to Disney's Alice in Wonderland and to Picasso, a stone's throw from the museum of the same name. The climax of this trip: the massive murals by Jef Aérosol, Choofy, Shepard Fairey and Invader.

FOLLOW THE GUIDE ↙

Starting at the Saint-Paul metro station, take <u>Rue Pavée</u>, then turn left onto <u>Rue du Roi-de-Sicile</u> ❶, where you will find some collages by Culkeen, Fred le Chevalier and

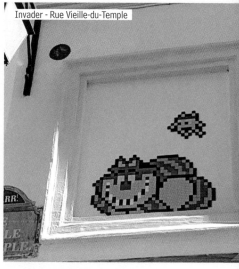
Invader - Rue Vieille-du-Temple

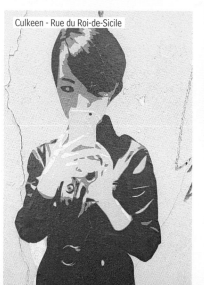
Culkeen - Rue du Roi-de-Sicile

others. At the end of the street, you will discover the smiling Cheshire Cat ❷ dreamed up and transformed by Invader.

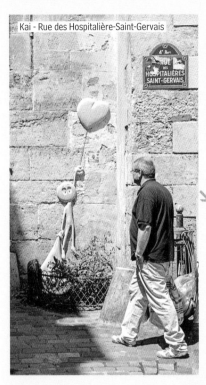

Kai - Rue des Hospitalière-Saint-Gervais

THE OCTOPUS PAINTS THE WALL

An invasion of octopuses in Paris? It must be GZUP! Pronounce 'Jeezup' and a reference to G'z Up, Hoes Down by Snoop Doggy Dogg. Simple eight-legged cephalopods or icons with tentacles, GZUP's creatures allude to Sega's Wonder Boy game.

Continue your walk by turning right onto <u>Rue Vieille-du-Temple</u>, which takes you to <u>Rue des Rosiers</u> ❸. You'll see the stamped collage of C+S and Missgreen_grenouille, and the work of Mosko. Take <u>Rue des Hospitalières-Saint-Gervais</u> ❹ to spot the big work by Gregos, as well as Heartcraft's crow taking off and Kai's imaginary friend.

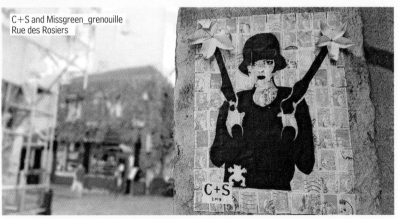

C+S and Missgreen_grenouille
Rue des Rosiers

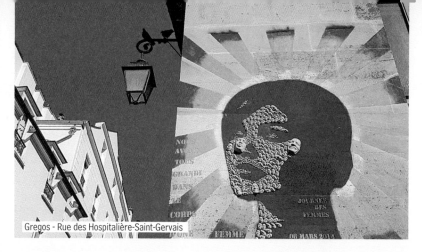

Gregos - Rue des Hospitalière-Saint-Gervais

⬎ Continue straight on to sneak down the cul-de-sac <u>Impasse des Arbalétriers</u> ❺, with FKDL and Mimi the clown. When you come out, turn left down <u>Rue des Francs-Bourgeois</u> ❻, where Line street and Backtothestreet have left their mark.

Turn left onto <u>Rue Elzévir</u> and continue to <u>Place de Thorigny</u> ❼ to say hi to Invader's Picasso a stone's throw from his museum. Continue straight on, where you'll see an attractive brunette ❽ in a bikini signed by the same artist.

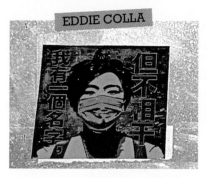

This photographer puts up stencils and stickers across the capital. His masked figures warn us about the appalling state the environment is in and the consequences for the human race.

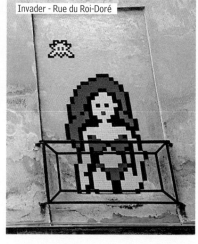

Invader - Rue du Roi-Doré

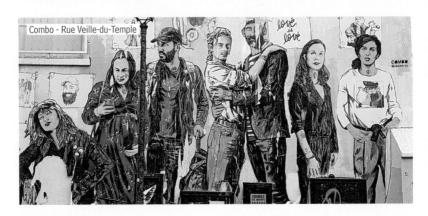
Combo - Rue Veille-du-Temple

Dive down <u>Rue des Coutures-Saint-Gervais</u> on your left to get to <u>Rue Vieille-du-Temple</u>. On your left and a little higher up on your right, have a look at the street art on the MuMa ➒ (the Marais Wall). Retrace your steps to get to <u>Rue de Bretagne</u> ➓, where Kai and Clet will be waiting to welcome you. Head down <u>Rue du Temple</u> as far as <u>Rue des Gravilliers</u>, which will be on your right. When on this street, <u>Rue des Vertus</u> ⑪ is worth a detour: it has various examples of street art, like this one by Wékup, recognisable from this watch that they always put on their work.

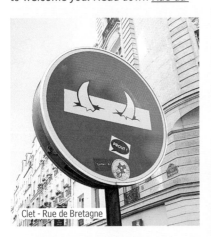
Clet - Rue de Bretagne

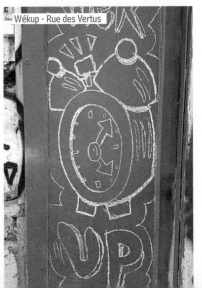
Wékup - Rue des Vertus

*Gentle and resolute, **Konny's** personality comes to the fore in her black-and-white portraits (occasionally with red stripes added). After haunting the Parisian metro between 2001 and 2005, this German artist now uses the streets as her playground.*

Her collages usually feature female figures from the world of fashion and publicity, crushed and worn out by that often cruel scene – such as Edie Sedgwick, Andy Warhol's muse in the sixties, who died of an overdose. More recent sources of inspiration are Cara Delevingne and Johnny Rotten. Konny cares about the environment and prefers the fragile technique of collage as it can be removed more easily. Her work is liberated and spontaneous yet still full of spirit. Konny has exhibited at Moretti & Moretti and at Mathgoth. She operates in Beaubourg, alone or accompanied for example by Mr Renard, and in Stalingrad.

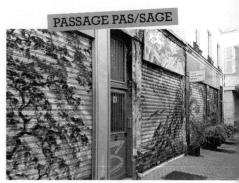

PASSAGE PAS/SAGE

The immersive experience of Passage Pas/Sage, initiated in 2012 by Christian Berst Art Brut and Sator galleries, is a celebration of contemporary and street art. Since 2016, Passage des Gravilliers has become the backdrop for the dreamlike universe of French graffiti artist unSolub.

↘ Go back to <u>Rue des Gravilliers</u> and head down the passage of the same name ⑫. At the end of the street, you will see Invader's Alice ⑬. Head towards <u>Rue Saint-Martin</u> via <u>Rue Chapon</u> ⑭ so you don't miss the work by 2Shy in that street. Go down <u>Rue Quincampoix</u> ⑮ to see a large work by Invader or Monsieur BMX's bicycle.

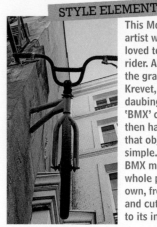

STYLE ELEMENT

This Montpellier artist would have loved to be a bike rider. After meeting the graffiti artist Krevet, he started daubing the word 'BMX' on walls and then hanging up that object, pure and simple. Monsieur BMX manages the whole process on his own, from recovering and cutting the bike to its installation.

NOT TO BE MISSED!

Finish your walk by taking a break in **Place Igor-Stravinsky** *to enjoy the comical fountain designed by Jean Tinguely and Niki de Saint-Phalle. As of 2011, the famous fountain has been sharing top spot with the massive artwork by Jef Aérosol, the pioneer of the stencil. Called Sshh!!!, this 350m² self-portrait on a building 22 metres tall took a week to complete. But an incredible amount of work went into preparing it, in particular in cutting the different layers. Incidentally, Jef Aérosol had the help of various stencil artists: Ender, Asfalt, Joseph Loughborough, David Amar, Fradelrico and Sevan Ahsan. A total of 200 spray cans were used to create this colossal work.*

In this genuine urban space, the artist's expression grabs you, inviting you to keep your eyes and ears open and (who knows?) make some surprising discovery in the midst of the surrounding cacophony.

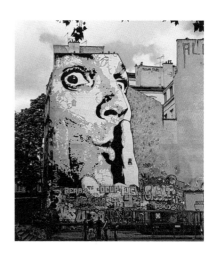

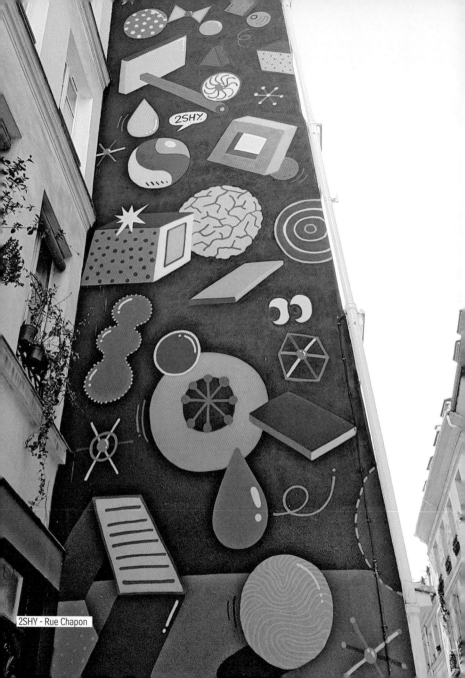

2SHY - Rue Chapon

↘ Turn left where you will see the work of VLP **16** and go to the corner of <u>Rue Saint- Martin</u> and <u>Rue du Cloître-Saint-Merri</u> **17** to discover the latest artist's sculpture, an initiative that is part of the Embellir Paris project.

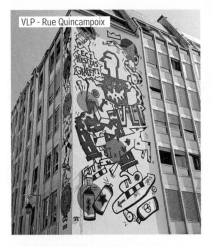
VLP - Rue Quincampoix

Hazul - Rue Quincampoix

Turn left to get to <u>Place Igor-Stravinsky</u> **18** where you can discover Jef Aérosol's wall (see p. 14), Shepard Fairey's last work and a massive Invader.

A REAL GEM

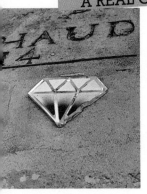

After experimenting with graffiti and stencils, Le Diamantaire is now focusing on mirrors as he draws on training in metalworking and boilerwork.
Since 2008, he has been scattering his diamonds across Paris.

Maïc Batmane - Rue Saint-Martin

GOOD TO KNOW

The **Urban Art Fair**, the leading event of its kind, takes place each year in Le Carreau du Temple, in the 3rd arrondissement. About thirty galleries take part in this fair promoting emerging talents and big names in street art, which lets you discover the work of around a hundred artists in an amazing location. The admission fee (€8 to €12) gives you access to a day's worth of talks too.

Le Carreau du temple
4 Rue Eugène-Spuller 75003 Paris
urbanartfair.com

Gzup et A2 - Rue du Temple

USEFUL ADDRESSES

BARS AND RESTAURANTS

① LE STAND PARIS
For a veggie lunch
39 Rue de Bretagne 75003 Paris •
+33 (0)6-21870888 Tue-Sat, 12:00-15:00

② PICK CLOPS
Raise a glass in a retro setting
16 Rue Vieille-du-Temple 75004 Paris •
+33 (0)1-402902 18 Every day 07:00-02:00

③ CAFÉ SUÉDOIS
Sit outside in a quiet courtyard
11 Rue Payenne 75003 Paris • +33 (0)1-42719979
Tue-Sun 12:00-18:00

BOOKSHOP

④ COMME UN ROMAN
For its selection and recommendations
39 Rue de Bretagne 75003 Paris
Tue-Sat 10:00-19:45, Sun 10:00-13:30
www.comme-un-roman.com

ART GALLERY

⑤ GALERIE MORETTI & MORETTI
For the artists on its books
6 Cours Bérard 75004 Paris • +33 (0)9-50902901
Tue-Sun 14:00-19:00
www.moretti-moretti.com

LOCAL ATTRACTIONS

⑥ POMPIDOU CENTRE
Place Georges Pompidou 75004 Paris

⑦ MUSÉE PICASSO
5 Rue de Thorigny 75003 Paris

⑩ LA PLACE (OFF THE MAP)
see p. 18

LA PLACE... TO BE

A Parisian cultural centre dedicated to hip hop? Opened in April 2016 at the same time as the Canopée, the amazing roof covering the Halles centre, this is the Place to be!

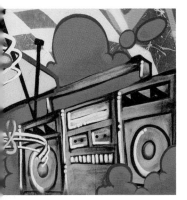

Hip hop, which started out as an anti-establishment sociocultural movement in the US in the 1980s, now has its own centre in Paris. Housed under the Canopée in the Halles, a focal point between Paris and the banlieues, La Place covers 1,400 m² with a music theatre (capacity 450), a studio for graffiti and street artists, two creative studios (for dance and music), a friendly bar, a broadcasting studio with seating for 100, DJ and Home studios and an incubator for hip-hop entrepreneurs.

La Place is a real hub with loads of activities aimed at promoting all forms of urban creativity. In particular their Hip-Hop Kidz programme for youngsters and families includes introductions to rap, beat box, hip-hop dance, DJing and – of course – graffiti.

As regards the last item, La Place aims to introduce the craze to a wide audience and improve people's understanding of it. It achieves this goal in part by highlighting artists working in studios, partner galleries or on one of the purpose-built walls, and in part by putting on exhibitions such as Paris History X of Graffiti, which traces the history of urban art and hip-hop graphics in Paris using photos, flyers and magazines.

Finally, La Place was put in charge of the artistic direction of the murals created through the 'Paris Murs Murs' programme. In this programme, with funding from the community budget, 20 walls will be painted in Paris's 20 arrondissements by 20 graffiti artists, all from the Île-de-France region.

Artists such as dAcRuZ, 2Shy, Lazoo and Vinie have already put effort into the project.

Follow La Place on Instagram, Facebook or other social media to get all the latest information.

LA PLACE – HIP HOP CULTURAL CENTRE
10 Passage de la Canopée, 75001 Paris
laplace.paris • Tue–Sat, 14:00–19:00

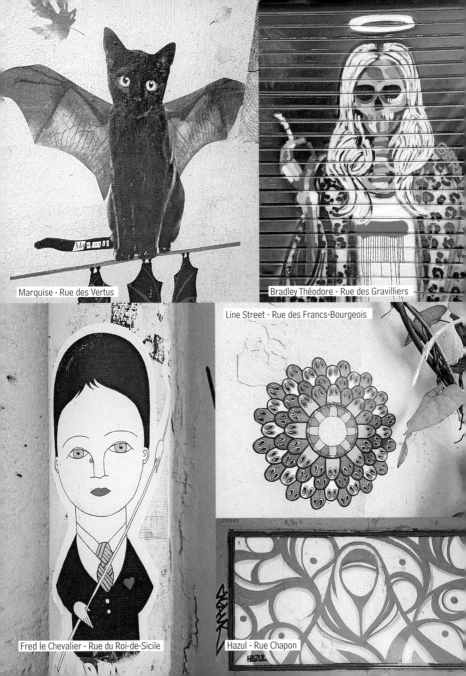

Marquise - Rue des Vertus

Bradley Théodore - Rue des Gravilliers

Line Street - Rue des Francs-Bourgeois

Fred le Chevalier - Rue du Roi-de-Sicile

Hazul - Rue Chapon

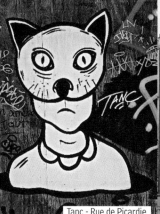
Tanc - Rue de Picardie

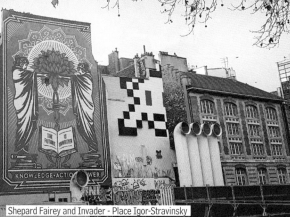
Shepard Fairey and Invader - Place Igor-Stravinsky

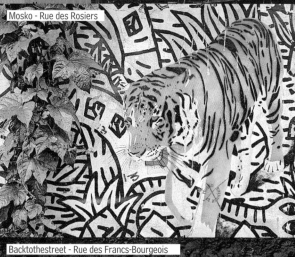
Mosko - Rue des Rosiers

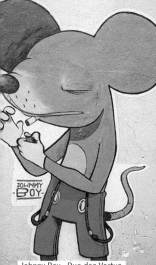
Johnny Boy - Rue des Vertus

Backtothestreet - Rue des Francs-Bourgeois

Heartcraft - Rue du Temple

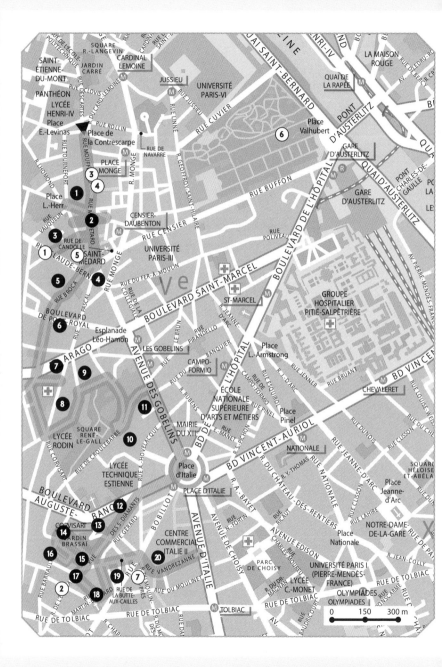

MOUFFETARD *and* BUTTE-AUX-CAILLES

The starting point for this walk, which takes two hours, is in Place de la Contrescarpe, close to the Panthéon. Enjoy a coffee at a pavement cafe before traipsing down Rue Mouffetard, which is long but far from boring. Then you enter Butte-aux-Cailles, a Parisian neighbourhood with a village feel, full of little houses and artists' studios. This maze of streets can be explored in any direction, revealing street art in a range of techniques: collages, mosaics, stencils, stickers and even chalk drawings.

FOLLOW THE GUIDE

As you walk down <u>Rue Mouffetard</u>, take a look at <u>Rue Jean-Calvin</u> ❶ and the surrounding passageways ❷ (<u>Postes</u>, <u>Patriarches</u>) where street artists regularly leave

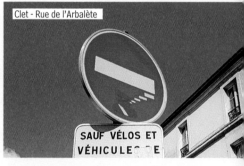
Clet - Rue de l'Arbalète

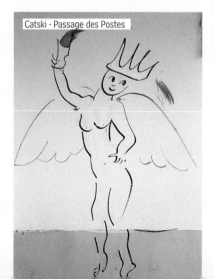
Catski - Passage des Postes

their mark. Take a detour down <u>Rue de l'Arbalète</u> ❸, where you will discover stencil art by Jef Aérosol and Artiste Ouvrier, among others. As you continue down <u>Rue Mouffetard</u>, keep an eye on the road signs as you are bound to see some that have been modified by Clet.

Jober - Rue Mouffetard

Wabi-Sabi - Rue Mouffetard

When you get to the end of the street, savour the atmosphere of the market (except Mondays). If it's a Sunday, enjoy the dancers performing next to Saint-Médard church. Turn off onto <u>Rue Édouard-Quenu</u> ❹ where street artists often operate.

Continue walking in the direction of the 13th arrondissement via <u>Rue Broca</u> ❺, where the white men of Mesnager, Poes and Jace meet up. Under the bridge ❻, you can find murals illustrating the children's stories Tales of the Rue Broca by Pierre Gripari. They were made by

THREE ARTISTS IN ONE MURAL!

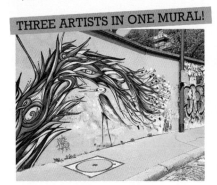

In Rue Croulebarbe, discover the universe of Anis, Otto Schade (alias Osch) and Eddie Colla in vividly coloured surroundings!

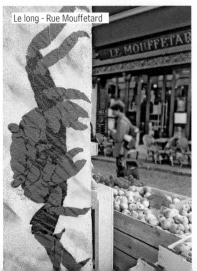

Le long - Rue Mouffetard

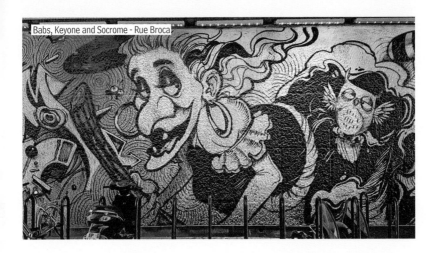

Babs, Keyone and Socrome - Rue Broca

Babs, Keyone and Socrome, of the artists' association LéZarts de la Bièvre. At the end of this street, cross Boulevard Arago to enter Rue de Julienne ❼ where you will discover the art of Seth. Turn back and take Rue Corvisart, which will bring you to Rue des Cordelières ❽ close to the park Square René-

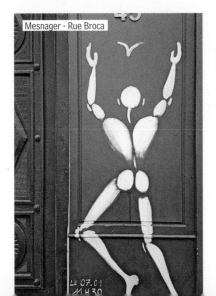

Mesnager - Rue Broca

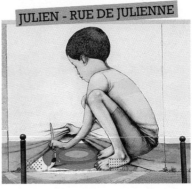

JULIEN - RUE DE JULIENNE

Tucked away in a small street in the 13th arrondissement, this artwork may be smaller than the others in this district but it is just as typical of the dreamlike world of Julien Mallard (alias Seth).

Le-Gall, where you can see the work by Seth and Kislow. Then head off down <u>Rue Émile-Deslandres</u> **9** where another massive work by Seth awaits you. Stroll down the edge of <u>Square René-Le-Gall</u> to get to <u>rue Croulebarbe</u> **10** on your left. This will let you see a mural featuring three leading street artists: Osch, Eddie Colla and Anis.

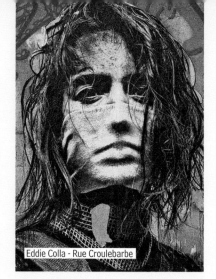

Eddie Colla - Rue Croulebarbe

ARTIST IN THE SPOTLIGHT

Jace lived on the island of Réunion for many years but he also regularly operates in the streets of Saint-Denis, his main haunt. He drew his first graffiti 'Gouzous' in 1992 and these characters can now be found in about thirty countries around the world. Jace's 'Gouzous' grace the walls and streets of Paris, sending highly topical messages with a dose of humour. Track them down in the 13th arrondissement, especially rue du Moulinet! But he doesn't restrict his activities to Paris! In 2019, Jace descended on Nancy where he created a tropical landscape on the Neurosciences building of the central hospital. As he did in the Parisian suburb of Grigny as part of the Wall Street Art de Grand Paris Sud festival (see p. 165).

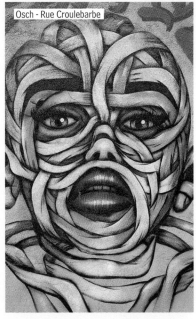

Osch - Rue Croulebarbe

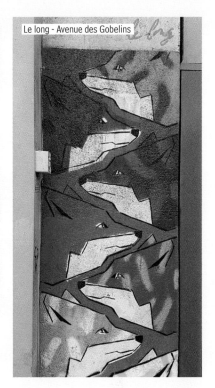

Le long - Avenue des Gobelins

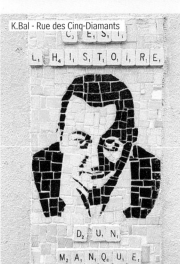

K.Bal - Rue des Cinq-Diamants

Turn onto <u>Avenue des Gobelins</u> **⑪** to admire Le Long's foxes or the hearts of Pochoirs pour tous covering up the messages denouncing assisted reproductive technology and turning these hateful notices into expressions of love (see p. 31). Walk up the avenue to Place d'Italie and take <u>Boulevard Blanqui</u> on your right, heading towards <u>Rue des Cinq-Diamants</u> **⑫**.

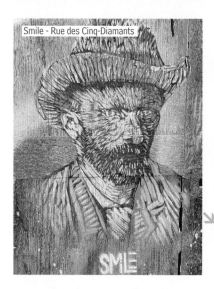

Smile - Rue des Cinq-Diamants

A SHARP CUSTOMER WHO STRIKES HOME

Provocative slogans + pretty brunette = Miss. Tic. Ever since 1985, this artist's stencils with their forceful texts have been catching the attention of passers-by.

Smile and the 2AC crew will be there to welcome you! Time to explore this atypical neighbourhood. Start with <u>Rue Jonas</u> **13** on your left, or

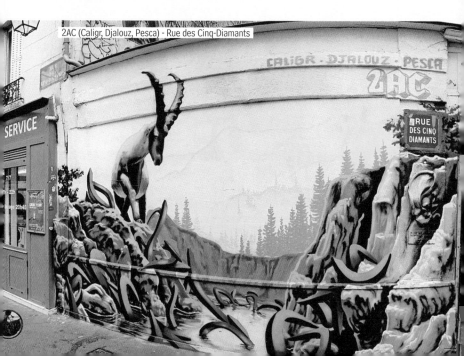

2AC (Caligr, Djalouz, Pesca) - Rue des Cinq-Diamants

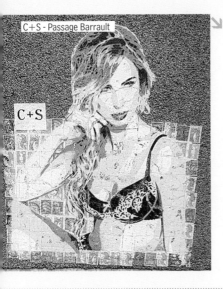

C+S - Passage Barrault

C+S

continue straight on and inspect the art in <u>Passage Barrault</u> ⑭ further along on your right, where you will find collages by various artists. This location is greatly prized by street artists and a wide diversity of new temporary creations are constantly being added. At the end is <u>Rue Barrault</u>. Turn left to stroll along <u>Rue Alphand</u> ⑮ and into <u>Passage Sigaud</u> ⑯, which boasts works by Jef Aérosol, Line street and M.Perre. Then walk on to <u>Place de la-Commune-de-Paris</u> ⑰

NOT TO BE MISSED!

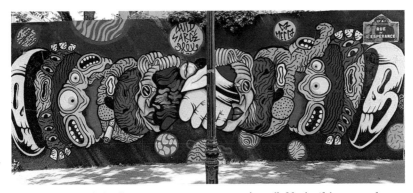

On advantage of the Butte-aux-Cailles district is the many permanent (or semi-permanent) artworks. Several of them are to be found around **Place de la-Commune-de-Paris**, one of the only 'large spaces' available in this maze of little streets, with works signed by leading street artists. This one is by the Mecca collective (Aulp, Flex, Sarcé).

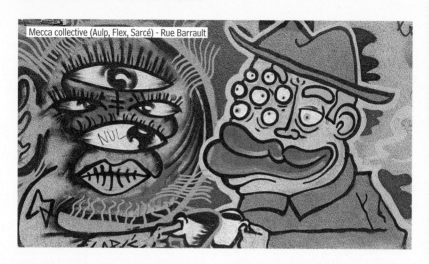

Mecca collective (Aulp, Flex, Sarcé) - Rue Barrault

and take the time to view artworks by the Mecca collective or those of Seth. Continue down <u>Rue Buot</u> **18** where you will be accompanied by Seth, Moyoshi, Selor and various other artists .

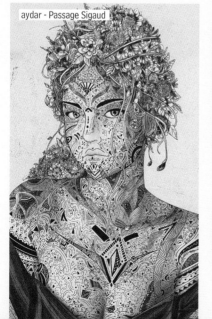

aydar - Passage Sigaud

Edward von Longus - Rue Alphand

REVISING THE ROUTE'S CODE

Pedestrians should keep an eye out for the road signs: when altered by stick artist Clet, they immediately take on a more friendly aspect.

STENCILS FOR ALL

Who are you?
We're a group of street art fans and we are fed up of seeing hateful anti-LGBT messages, shocking slogans opposing assisted reproductive technology and rigged polls on Parisian pavements.

Why do you take action on the street?
You can't let the streets just say anything. If you stand by, you are supporting the degradation of the public space, the banal homophobia in those messages and the lack of a response from the municipality of Paris.

What triggered you?
In August 2018, Paris hosted the Gay Games, which are all about diversity, open to everyone and celebrating tolerance. But how can we tolerate the fact that LGBT people who've come from all over the world have to see these defamatory, deceitful messages? We really felt ashamed and we asked ourselves how we should respond. We picked up some cardboard, cut out a heart and that was the start of our campaign...

What is your main source of inspiration?
We wanted to produce useful street art. We decided it was better to use a gentle, pacifist method to address people – hence the hearts. We also wanted something that would be easy to make so that as many people as possible could copy our approach and do the same. Then we used social media to explain our action, tell people about the issues in the revision of the French law on bioethics and pass on the stories of individuals actually affected by this.

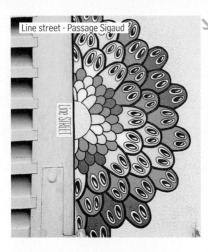

Line street - Passage Sigaud

Line STREET

↘ Head off down <u>Passage Boiton</u> **19** to see Baudelocque's hippo and crane (the bird, not the hoisting equipment!) done in cha▮

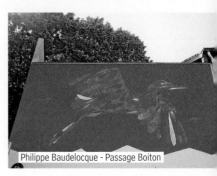

Philippe Baudelocque - Passage Boiton

NOT TO BE MISSED!

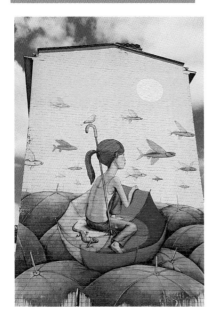

*Halfway through the route, a change of scale with **Seth!** After crossing boulevard Arago, continue down Rue des Cordelières. On your left (2, Rue Émile-Deslandres), admire a mural created in June 2013 as part of the LéZarts de la Bièvre festival, where the artist was in the spotlight. Then return to <u>Rue des Cordelières</u> (no. 29) for a colossal Seth/Kislow collaboration dated August 2013. In 2018, still as part of the LéZarts de la Bièvre, Seth marked out the route again to point people to various artists' studios. Keep your eyes open in the streets of Butte-aux-Cailles and you won't be disappointed.*

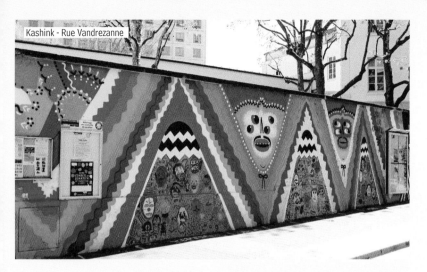

Kashink - Rue Vandrezanne

For a grand finale, how about a collaborative mural that is certainly original? Take <u>Rue Vandrezanne</u> **20** to admire the artwork that Kashink created with the kids from the local nursery school.

ORWEGIAN IN RUE DE LA GLACIÈRE

STRØK's massive mural livens up Rue de la Glacière (off the map). At 22 metres tall, it shows the movements of four hip hop dancers as if seen from above.

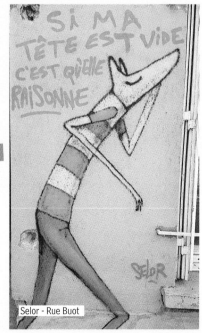

Selor - Rue Buot

GOOD TO KNOW

Since 2001, the association LéZarts de la Bièvre has offered themed walks in the second weekend of June introducing people to artistic techniques and artists' studios. Each edition of the festival highlights one particular artist, with works created specially for the occasion and marking out the various routes.

www.lezarts-bievre.com

USEFUL ADDRESSES

BARS AND RESTAURANTS

① LA BELLE MINE
For its friendly vibe and tastings of natural wine
58 Rue Claude-Bernard, 75005 Paris •
+33 (0)9-86455190
Mon-Sat 10:00-01:00, Sun 11:00-23:00

ⓞ LES 5 SAISONS (OFF THE MAP)
Food based on traditional Chinese dietary concepts
52 Boulevard Arago, 75013 Paris •
+33 (0)9-86771323 Mon-Tue 12:00-15:00/19:00-22:30, Thu-Sat 12:00-15:00/19:00-23:00
les5saisons.paris

② LA FOLIE EN TÊTE
For its musical decor
33 Rue de la Butte-aux-Cailles, 75013 Paris •
+33 (0)1-45806599 Mon-Sat 17:00-02:00
lafolieentete.wix.com/lesite

③ DOSE – DEALER DE CAFE
For its coffee and cosy setting
73 Rue Mouffetard, 75005 Paris •
+33 (0)1-43366503
Tue-Fri 08:00-18:00, Sat-Sun 09:00-19:00

④ LE SWEETSPOT
For its spreads
108 Rue Mouffetard, 75005 Paris •
+33 (0)9-81494545
Tue+Sat 10:00-19:00, Wed-Fri 08:30-19:00, Sun 10:00-18:00
lesweetspot.paris

BOOKSHOP

⑤ LES TRAVERSÉES
Run by real enthusiasts
2 Rue Édouard-Quenu, 75005 Paris •
+33 (0)1-43317408
Mon-Sat 10:00-19:30, Sun 10:00-13:30
www.lestraversees.com

LOCAL ATTRACTIONS

⑥ JARDIN DES PLANTES
Botanical garden for some greenery after all that urban art
57 Rue Cuvier, 75005 Paris
www.jardindesplantes.net

⑦ BUTTE-AUX-CAILLES SWIMMING POOL
Art Nouveau facade and solarium
5 Place Paul-Verlaine, 75013 Paris
meslieux.paris.fr

ⓞ LES GRANDS VOISINS (OFF THE MAP)
Unusual Left Bank location!
82 Avenue Denfert-Rochereau, 75014 Paris
lesgrandsvoisins.org

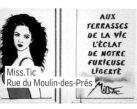

Miss.Tic
Rue du Moulin-des-Prés

Lady Bug
Rue du Moulin-des-Prés

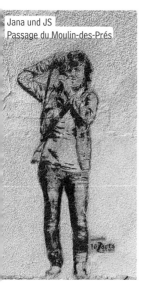

Jana und JS
Passage du Moulin-des-Prés

MOUFFETARD/BUTTE-AUX-CAILLES, A ROUTE WITH VARIED TECHNIQUES

It is always surprising to find so many street art works using such a range of techniques in this rather smug residential district. They are undoubtedly a reminder that only fifty years ago, these streets near the Latin Quarter, the scene of demonstrations in the May '68 uprising, or adjoining Place de la Commune-de-Paris, were the left bank of these real working-class islands.

TAGS AND STENCILS, IN URBAN ART FROM THE START

The tag is at the forefront of the techniques used by street artists. It was the French-American artist Philippe Léhman, aka Bando, who introduced this New York graffiti style to France in the 1980s and developed it further. With his old-school lettering, he became legendary and the number one enemy of the Parisian transport service. A tag, often created used a spray-can, is the author's signature (their pseudonym).

Stencils abound in this district, whether signed by Jef Aérosol or Miss.Tic. This technique, which consists of cutting out the letters of a phrase or an entire drawing from a rigid material, is very popular with artists because it can be executed so quickly on location. While preparing the stencil is a lengthy, meticulous process, an advantage is that you can reuse it multiple times, and customise it by applying different layers to get an attractive composition and interesting colours.

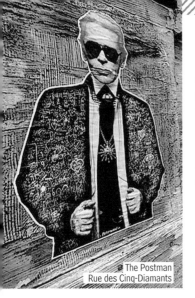

The Postman
Rue des Cinq-Diamants

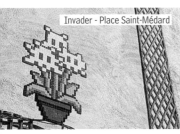

Invader - Place Saint-Médard

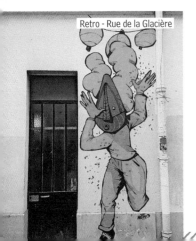

Retro - Rue de la Glacière

COLLAGES, STICKERS, MURALS AND MOSAICS: STREET ART FINDS ITS FEET

Collage is also on the programme in this walk. Like stencils, a collage is prepared in advance in the artist's studio and can be put up on a wall quickly with the aid of some glue and a pole, which is a plus when operating at night at -3°C. This technique is preferred by local residents and the owners of the walls because the artwork is subject to the vagaries of the weather and it doesn't take much effort to remove – unlike tags. What is more, the Criminal Code says that someone 'caught in the act' of sticking up a collage without prior permission from the wall's owner will get a relatively small fine of €3,750 plus community service, whereas a graffiti artist can get a fine of €30,000 and two years in prison into the bargain. It is therefore hardly surprising to see collages flourishing in Paris.

Put your guide to one side and inspect the facades for evidence that Invader has been here – Rue du Moulin-des-prés or Rue Chéreau for example. This street artist has made the mosaic his technique of choice for creating his 'Space Invaders', pixellated creatures that have escaped from video games – and he has been doing this for twenty years! K.Bal has also used this technique in Rue des Cinq-Diamants to pay homage (in a Scrabble version) to French comedian Coluche on what would have been his 70th birthday in 2014: "It's the story of a gap".

matt_hieu – Rue de l'Arbalète

matt_hieu – Rue Jean-Calvin

THE LATEST ADDITION — CHALK

Just a piece of chalk is enough to make your mark in the street! First used in urban art by Keith Haring (the artist started doing chalk drawings on the black advertising panels on the New York subway), this trend marks a more stripped-down form of street art, more modest and poetic too. You will find artworks by matt_hieu and Philippe Baudelocque scattered throughout this route. Matt_hieu uses this technique for two reasons: his chalk art 'respects' the site, whether shop walls or the facades of blocks of flats (you can hardly call it 'defacing') and it meets a demand for less permanent works that evolve and then leave space for other artists to express themselves. This popular technique has since been used on the capital's roads and infrastructure, for example in the labyrinthine paths created by Jordane Saget that abound in the 1st and 10th arrondissements.

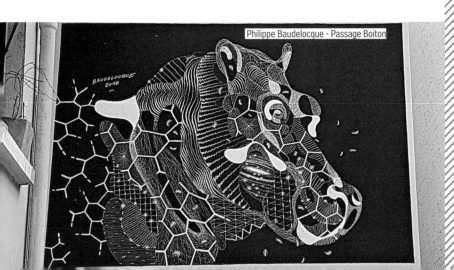

Philippe Baudelocque - Passage Boiton

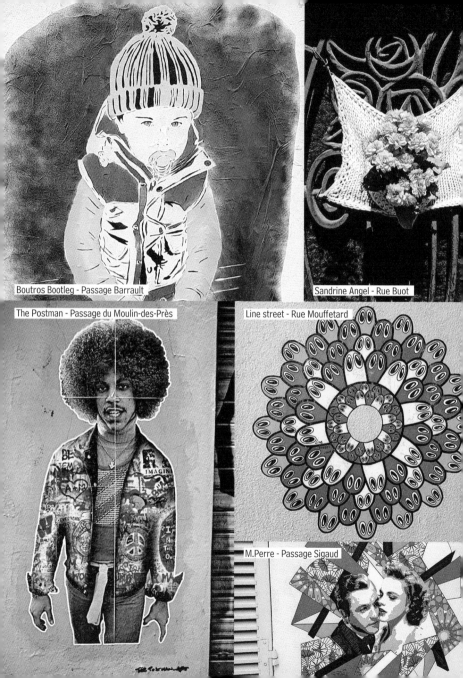

Boutros Bootleg - Passage Barrault

Sandrine Angel - Rue Buot

The Postman - Passage du Moulin-des-Près

Line street - Rue Mouffetard

M.Perre - Passage Sigaud

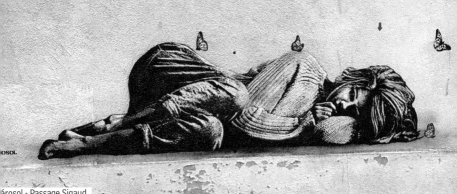

Aérosol - Passage Sigaud

Bom-Sabi - Rue des Lyonnais

Seth - Rue Buot

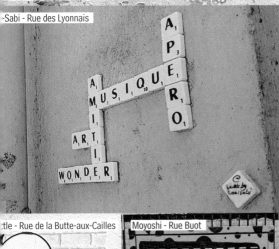

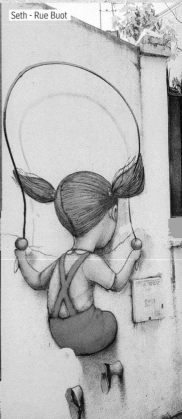

Little - Rue de la Butte-aux-Cailles

Moyoshi - Rue Buot

"There is more of the good than the bad in this old rugged World"

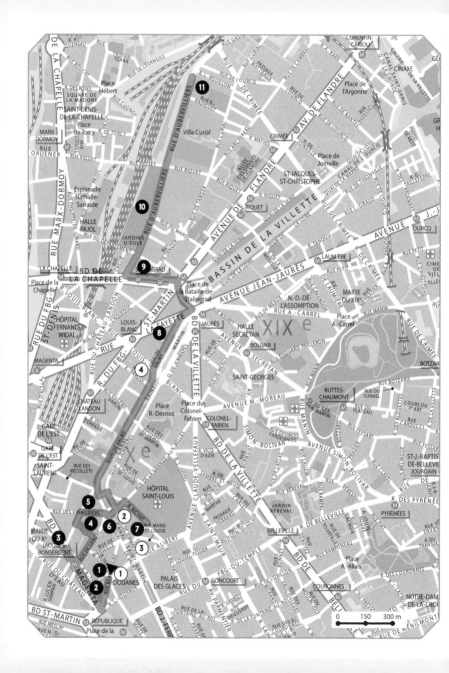

ᖴROM THE RÉPUBLIQUE

to **104**

This walk of around ninety minutes takes you across three arrondissements. You roam round the 11th, then stroll along quayside through the 10th to get to the 19th. On the programme are works by Levalet, Chanoir, Invader, Fred le Chevalier, Noarnito etc. and a stop at the Point Éphémère arts centre, whose surroundings abound in street art in all its forms. You end this walk with the last mural in the district, the one by MioSHe close to the 104 Centre. If you have more time, you can combine this visit with the walk from Stalingrad to Pantin (see p. 98).

FOLLOW THE GUIDE

Starting at Place de la République, take Rue Beaurepaire 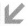 and admire the lettering by Toqué Frères: "La vie est belle, et vous êtes comme elle" (Life is beautiful and so are you). Get back onto Boulevard Magenta (cast a glance down the Cité Wauxhall ❷ as you pass by).

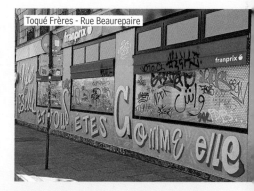
Toqué Frères - Rue Beaurepaire

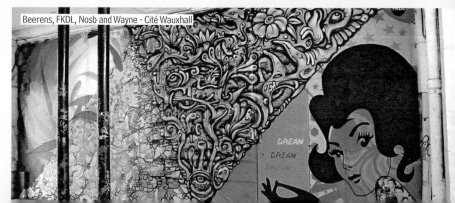
Beerens, FKDL, Nosb and Wayne - Cité Wauxhall

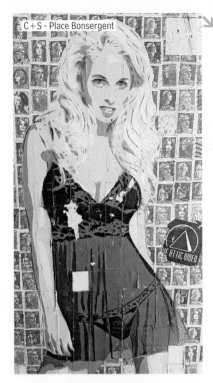

C+S - Place Bonsergent

At the point where it meets <u>Place Jacques-Bonsergent</u> ❸, you have a clear view of the Eiffel Tower — revisited and reworked by Clet in the middle of a road sign — and an Invader that's taken root above a bakery. Retrace your steps and take <u>Rue de Lancry</u> towards <u>Rue Legouvé</u> ❹ on your left.

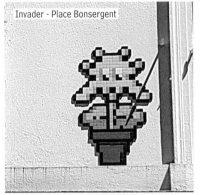

Invader - Place Bonsergent

Kraken - Place Bonsergent

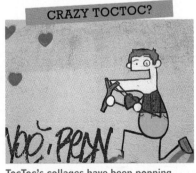

CRAZY TOCTOC?

TocToc's collages have been popping up around Paris since 2011. Inspired by Keith Haring's universe, TocToc shows a lot of humour in the way he appropriates the space.

NOT TO BE MISSED!

Founded in 2010, **3 murs** is an operation run by the community council for Hôpital-Saint-Louis-Faubourg-du-Temple in Paris's 10th arrondissement.

Seven walls are available for artists based on a schedule reserving them for specific projects. The selected artworks are always kept for six months.

The council provides the paint and the artist or collective must respect some basic rules: no messages that are sexual, political or religious in nature. In agreement with the owners and the town hall, if there is any dispute the wall will be painted over. These rules have never once been broken in the past ten years.

The artist or collective is then assigned to one of the walls.

If required, they are paired with a school to set up a joint project. The walls managed by the council are:
- 24, Rue Alibert
- 10, Rue Jacques-Louvel-Tessier (in partnership with ARERAM)
- Rue d'Aix (where it meets Rue Jacques-Louvel-Tessier)
- 40, Rue Sambre-et-Meuse
- 99, Rue du Faubourg-du-Temple
- 38, Rue Sainte-Marthe
- 24, Rue des Récollets

You can see some of them on this route but feel free to make a detour to spot others as the programmed artworks are all worth a look. The programme has included both French and international artists, for example Felipe Yung, Thiago Thipan, Zeh Palito, Beerens and Dourone.

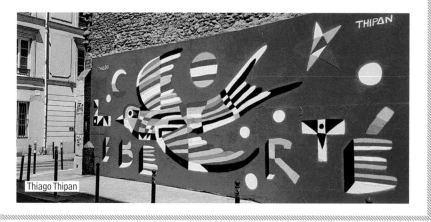

Thiago Thipan

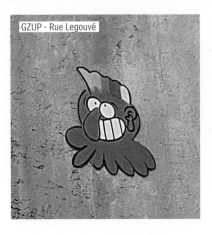

GZUP - Rue Legouvé

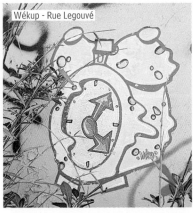

Wékup - Rue Legouvé

↘ You will find a wall managed by the 3 Murs (see p. 43), which artists can use for a period of six months. Turn right onto <u>Rue Lucien-Sampaix</u>. You will spot a Space Invader, then a second one in <u>Rue des Vinaigriers</u> ❺, and continue along <u>Rue Jean-Poulmarch</u> ❻, which has a mural by Vinie close by.

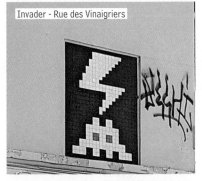

Invader - Rue des Vinaigriers

HUMAN COMEDY

Levalet installs his life-sized figures on walls using paper and ink. A master in staging a scene in carefully chosen locations, this plastic arts teacher knows how to appeal to the general public.

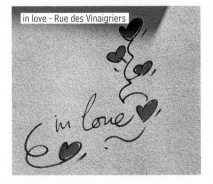

in love - Rue des Vinaigriers

FKDL

Who are you?

My name is Franck Duval. I first used my artist's name of FKDL in 2000 when I discovered Tape Art as a technique.

When did you start working in the streets and why?

At the time of the exhibition Aux Arts Citoyens (2006) in Paris, which I took part in using this collage technique with transparent sticky tape. The main reason for me to start working in the street was to add colour wherever I go, brighten up the dull grey walls and recycle all those vintage magazines that I've been collecting for years with an iconography I love. I've kept to that ever since.

What triggered you to start doing street art?

I've always wanted to bring a group of characters to life. Over time, that group has grown and now mainly consists of women (with a few exceptions that prove the rule). The freedom I have in the streets is another trigger: I've acquired a taste for it and can't do without it now.

What is your main source of inspiration?

Above all, I believe in humanity and the encounters that go with that. I draw on that every day. I also get inspiration from exchanges, from sharing, from love, from generosity, from people who open up to me, from listening, observing, reflecting and so on. Everything in the real world, not from sitting hidden behind a screen.

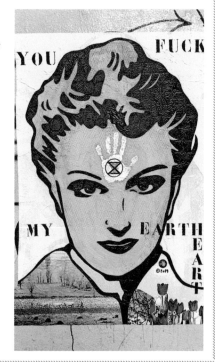

Cross <u>Saint-Martin canal</u> using the Grange-aux-belles bridge, continue down the street of the same name and take a left down <u>Rue Bichat</u> ❼, home territory for Chanoir's cats as well as Toqué Frères, with their lettering "Confiance" (trust).

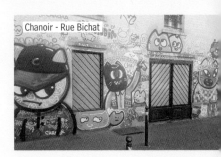

Chanoir - Rue Bichat

ARTIST IN THE SPOTLIGHT

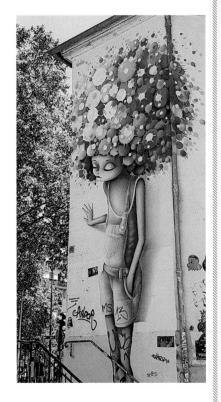

*Originally from Toulouse, **Vinie** has been working with graffiti since secondary school, focusing on text art. Jams and other thematic murals allowed her to diversify. In 2007, when she moved to Paris to work as an artistic director, she shifted to a more figurative style. The capital's walls saw her portraits appear – rather pin-up like dolls, often with hair decorated with tags, the artist's signature.*

She found out about working with volumes in 2013 when she met Anti. Her murals integrate real-life elements such as ivy, expressing her concern about environmental issues. Much in demand for exhibitions, festivals and murals – her work on the M.U.R. Oberkampf wall in 2015 got a lot of attention – Vinie has a career divided between the streets and art galleries, in France and abroad.

Retrace your steps and go back up <u>Quai de Jemmapes</u>. Cross the canal again and turn right onto <u>Quai de Valmy</u>. When you get to no .200 ❽, take a break at the Point Éphémère centre whose facades are dedicated to street art. Continue to the end of the quay, heading towards cultural centre Rotonde-Stalingrad

FROM REALISM TO DONATIONS

Pboy takes over the capital's walls with his realist murals. His special trick? He's the first artist to suggest Bitcoin donations via a QR code that you can find on his works. This lets him maintain his creative independence.

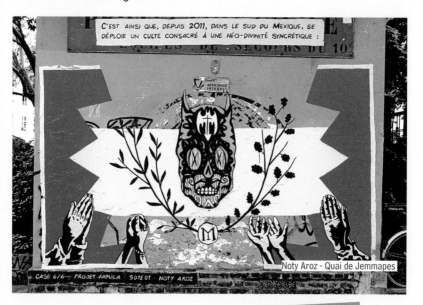

C'EST AINSI QUE, DEPUIS 2011, DANS LE SUD DU MEXIQUE, SE DÉPLOIE UN CULTE CONSACRÉ À UNE NÉO-DIVINITÉ SYNCRÉTIQUE :

CASE 6/6 · PROJET FABULA · S01E01 · NOTY AROZ

Noty Aroz - Quai de Jemmapes

PUTTING A SMILE ON THE CITY

"Life is beautiful and so are you", "Love is fine!", "Trust"... Since 2015, the Toqué brothers have been adorning the streets of Paris with their poetic and invariably positive text art. These days, the two brothers also organise participatory workshops for disadvantaged youngsters.

THE MAN IN WHITE

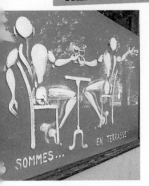

Major artist Jérôme Mesnager, started off in cabinetmaking and comic books. He now livens up Paris with his white silhouettes. His works include Nous sommes... en terrasse (We are outside a cafe), a homage to the victims of the Parisian terrorist attacks in 2015.

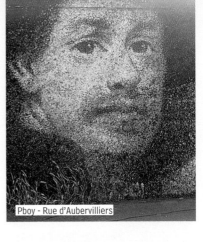

Pboy - Rue d'Aubervilliers

(Place de la Bataille-de-Stalingrad) and Stalingrad station to admire Lazoo's wall in Boulevard de la Villette, near no. 242 **9**. Stroll down Rue d'Aubervilliers and into the Jardins d'Éole **10** for Chanoir's work again in a playground and murals e.g. by Lotfi Hammadi. This takes you to the 104 Centre, where the walk ends with a flourish with MioSHe's monumental mural at no. 156 **11**.

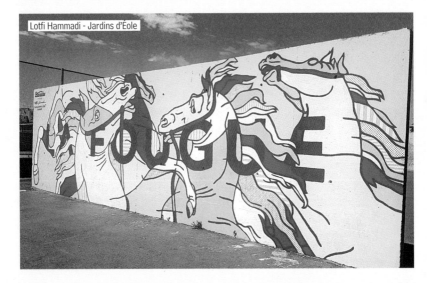

Lotfi Hammadi - Jardins d'Éole

GOOD TO KNOW

Two hubs that nurture urban culture:

Le Point éphémère, whose walls are regularly adorned by street artists, has a great programme of concerts and exhibitions.
200 Quai de Valmy, 75010 Paris
www.pointephemere.org

104, housed in an old municipal funeral parlour, has won recognition as a leading cultural and multidisciplinary centre, with exhibitions, shops, restaurants and performances.
104 Rue d'Aubervilliers, 75019 Paris
www.104.fr

USEFUL ADDRESSES

BARS AND RESTAURANTS

① IMA CANTINE
Delicious veggie Mediterranean flavours
39 Quai de Valmy, 75010 Paris •
+33 (0)1-40515814
Mon-Fri 08:00-22:30, Sat-Sun 10:00-22:30
www.ima.paris

② TEN BELLES
For a great coffee break
10 Rue de la Grange-aux-Belles, 75010 Paris •
+33 (0)1-42409078
Mon-Fri 08:00-17:00, Sat-Sun 09:00-18:00
www.tenbelles.com

③ LA VACHE DANS LES VIGNES
For an exceptional wine and cheese experience

46 Quai de Jemmapes, 75010 Paris
Mon-Tue 16:00-22:00, Wed-Sat 12:00-22:00
lavachedanslesvignes.fr

④ LA MÉDUSE
The right vibe for any time of day
177 Quai de Valmy, 75010 Paris •
+33 (0)1-11412853 Wed-Fri 17:00-23:45,
Sat-Sun 11:00-15:00/17:00-23:45
lameduseparis.com

BOOKSHOPS

⒪ L'ACACIA
Because the staff are so nice
33 Boulevard du Temple, 75003 Paris
+33 (0)1-48047652 • Mon-Sat 10:30-19:30

⒪ LA RUBRIQUE À BULLES
For comic book fans
110 Boulevard Richard-Lenoir, 75011 Paris
+33 (0)1-43384515 • Mon-Sat 10:00-20:30
www.canalbd.net/la-rubrique-a-bulles

ART GALLERIES

⒪ MAGDA DANYSZ GALLERY
78 Rue Amelot, 75011 Paris • +33 (0)1-45833851
Tue-Sat 11:00-19:00
www.magda-gallery.com

⒪ GALERIE OPENSPACE
For its programme and documenta- tion centre
116 Boulevard Richard-Lenoir, 75011 Paris
+33 (0)9-80666394 • Wed-Sat 14:00-19:00
www.openspace-paris.fr

LOCAL ATTRACTIONS

⒪ QUAI 36 DE LA GARE DU NORD
18 Rue de Dunkerque
www.quai36.com

ZOOM IN ON...
THE GFR COLLECTIVE

At the end of this route, from Rue d'Aubervilliers to Rosa Parks station, the association GFR has introduced creative dynamism with its large-scale projects in the heart of the neighbourhood.

Among the artistic and participatory projects being implemented in public spaces is the wall of the suburban railway station Rosa-Parks. Along with funding from the city of Paris's participatory budget (urban revitalisation section), it was made possible by a partnership between the 18th and 19th arrondissement municipalities and the national railway company SNCF. At more than 500 metres, this mural is the longest in north-eastern Paris. It bears witness to the fight against discrimination and for equality and peace associated with the American activist Rosa Parks and has made a lasting impression since it was created to mark the opening of the station in 2015. Five international artists, four of them women, were invited to get creative on the wall separating the street from the railway track: Katjastroph (Nantes), Bastardilla (Bogota), Tatyana Fazlalizadeh (New York), Zepha (Toulouse) and Kashink (Paris).

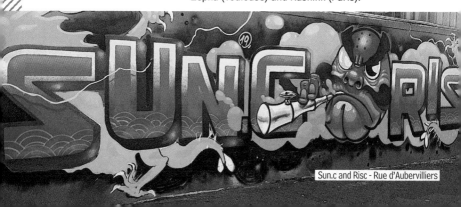

Sun.c and Risc - Rue d'Aubervilliers

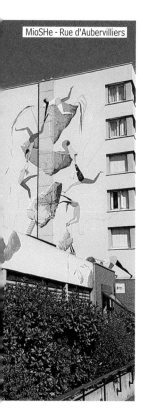

MioSHe - Rue d'Aubervilliers

An open-air gallery has been set up by the association R'Style and the collective GFR on Riquet bridge (where you can find work by Pboy). New works by different artists are constantly appearing on these surfaces even though the mural was originally intended for demolition.

The GFR collective has also managed a collaborative project with residents, neighbourhood associations and the artist MioSHe from Rennes. In the course of this project, locals became involved in the issue of love and trust among young people in public spaces as they answered the questions of whether you can express your love freely, whether love should be invisible and hidden in order to exist or needs to be on show to all and sundry, and "Are these gestures gendered?" MioSHe then interpreted the different testimonies and turned them into a large, colourful mural 20 metres tall entitled Rising in Confidence.

The latest project managed by the collective is a mural by Fred Calmets in Rue Didot in the 14th arrondissement (off the map) that pays homage to the artist Zao Wou-Ki.

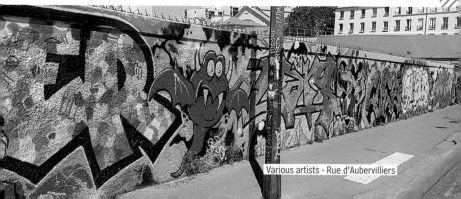

Various artists - Rue d'Aubervilliers

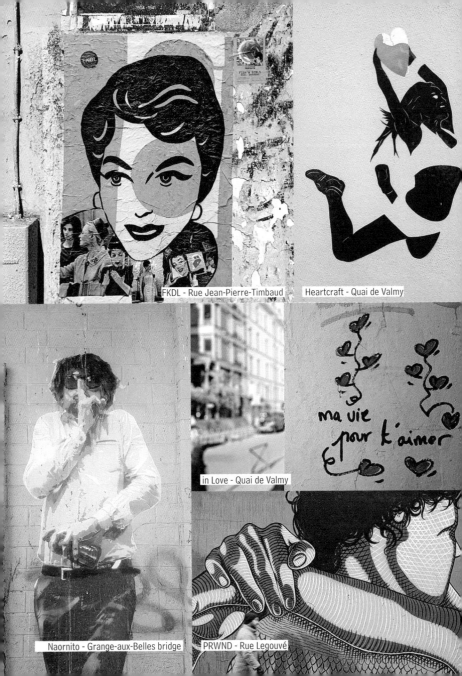

FKDL - Rue Jean-Pierre-Timbaud

Heartcraft - Quai de Valmy

in Love - Quai de Valmy

ma vie pour t'aimer

Naornito - Grange-aux-Belles bridge

PRWND - Rue Legouvé

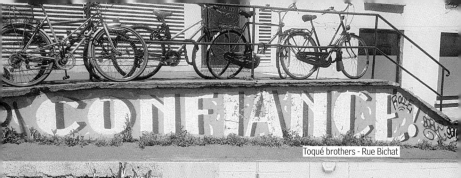
Toqué brothers - Rue Bichat

Polar Bear - Rue d'Aubervilliers

Manyoly - Quai de Jemmapes

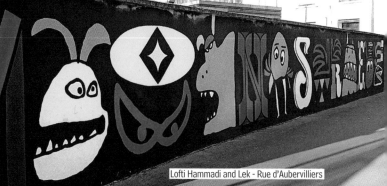
Lofti Hammadi and Lek - Rue d'Aubervilliers

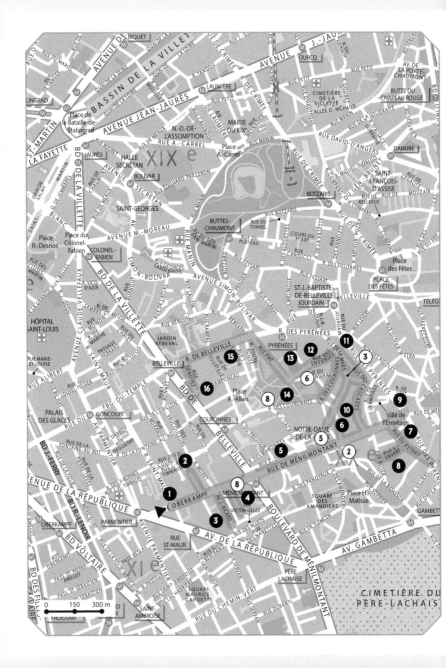

ROM OBERKAMPF
to BELLEVILLE

A neighbourhood with a long tradition of urban art, as is evident in various places such as Rue Dénoyez, famous for its artists' studios and profusion of murals. These initiatives are showcased in this route of about two hours, from the wall managed by the association Le M.U.R. to the dedicated street art spaces where Art Azoï offers a great programme of artists. You start in Oberkampf, then head down Ménilmontant and on to Belleville park with its amazing views and works by Seth along the promenade. Then go back downhill towards Belleville.

FOLLOW THE GUIDE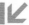

You start at Oberkampf Wall, at Place Verte, the point where <u>Rue Saint-Maur and Rue Oberkampf meet</u> ❶. This must-see spot gets a new artwork every two weeks, as announced on the website of the association that manages the wall (www.lemur.fr). Set a date to watch the artist at work from the comfort of pavement cafe Place Verte. More than 250 artists have exhibited their work here, including Gérard Zlotykamien, Rero, Alëxone, Speedy Graphito, Jana und JS, and more recently RNST, WELSH, Ardif and Reso (see the photo).

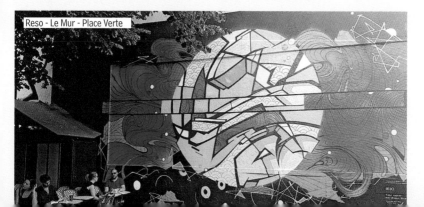

Reso - Le Mur - Place Verte

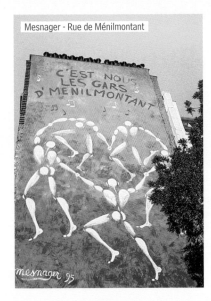
Mesnager - Rue de Ménilmontant

urban print. Cross the boulevard and continue along <u>Rue de Ménilmontant</u> ❺, where you can feast on a NEMO, followed by Mesnager's homage to the cabaret singer and local boy Maurice Chevalier. In collaboration with the municipality and drawing on a state support programme, Art Azoï assisted the production by ATLAS (<u>2, Rue Henri-Chevreau</u>) ❻.

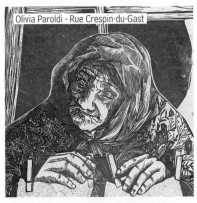
Olivia Paroldi - Rue Crespin-du-Gast

Walk up <u>Rue Oberkampf</u>. Collages adorn <u>Cité Griset</u> ❷ while <u>Avenue Jean-Aicard</u> ❸ has had a visit from Monsieur BMX. When you get to <u>Rue Crespin-du-Gast</u> ❹ a bit further along, take a look at Olivia Paroldi's

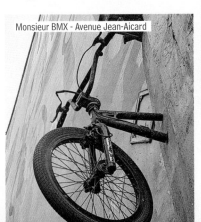
Monsieur BMX - Avenue Jean-Aicard

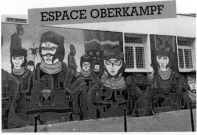
ESPACE OBERKAMPF

Espace Oberkampf is a gallery at the intersection of Avenue Jean-Aicard and Rue d'Oberkampf. Opened in 2019, it has indoor exhibition space and an exterior wall 21 metres long. The photo shows a mural by Didier Jaba Mathieu.

Signalement : yeux bleus, cheveux chatains
Jane B. :? anglaise de sexe féminin, âge entre vingt et un
apprendre le dessin. Domiciliée chez ses parents, yeux bleus, cheveux chatains, Jane B..., teint pâle

Singular Vintage - Cité Griset

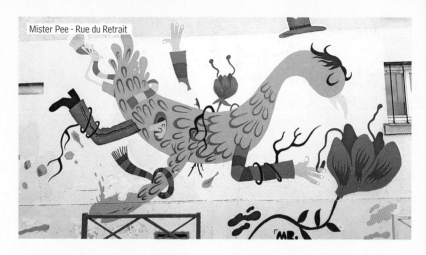

Mister Pee - Rue du Retrait

⟋ Thread your way down <u>Rue du Retrait</u> ❼ and <u>rue Laurence-Savart</u> ❽ in the company of Mister Pee, Mosko and Anis, among others, before stopping at <u>no 121, Rue Ménilmontant</u> ❾, with the wall managed by Art Azoï in front of the Carré de Baudouin.

Retrace your steps to get onto <u>Rue des Cascades</u> ❿ (works by various artists). Explore the adjoining streets (such as Rue de la Mare, Rue de Savies and Rue des Couronnes) ⓫ to make your acquaintance with Alex, Le CyKlop, Philippe Hérard and more.

CASCADING MURALS

Every two months, the Cascades gallery invites artists to create an artwork on the wall of Les Mésanges bistro, **Place Henri-Krazucki**. Artists who have taken up the invitation to date include Eddie Colla, Jimmy C, 13bis and (shown here) Soma Difusa.

Manyoly - Rue des Cascades

NOT TO BE MISSED!

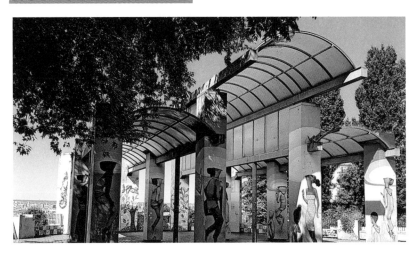

The steep climb is worth it! On top of awesome views of Paris, **the promenade in Belleville park** has a major surprise in store for you! Seth has redecorated both the promenade and the amphitheatre, tailoring his creations to the architecture of these sites.

These artworks are thanks to two players in Parisian street art. The first is the Art Azoï association, which has been successful in promoting street art on various surfaces and highlighting talented French and international artists, such as Vinie, JBC and Jace, while developing and maintaining spaces for the art and creating a link between the artworks and the local community. The second is the municipality of the 20th arrondissement (in partnership with the green spaces in Paris), which is determined to make the district the place to be for street art.

UNDERCOVER

The stencil artist and actor Ender has lived in Belleville for 25 years. The district is full of his artworks that mix collage with stencils — a technique that avoids the risk of getting nabbed while waiting for multiple stencil layers to dry.

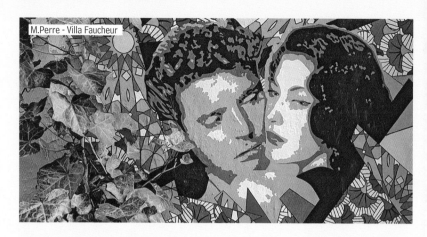

M.Perre - Villa Faucheur

A change of scene! Take <u>Rue des Envierges</u> ⑫, have a look at <u>villa Faucheur</u> ⑬ then head off towards the <u>lookout spot in Belleville park</u> ⑭, where you can enjoy one of the most impressive panoramic views of the capital in a setting enlivened by the colours of Seth (see p. 59). The walk continues down <u>Rue Piat and Rue de Belleville</u> ⑮ with surprises including "Il faut se méfier des mots" (don't trust words), signed Ben.

Retro - Rue du Retrait

HOPARE OFFLINE

Ever since his adolescence, **Hopare** has hung out in abandoned sites with his mates, with the support of Marchal Mithouard (Shaka) who taught him art and later became his mentor. His style of interlacing lines of colour reveals surprising portraits.

ARTIST IN THE SPOTLIGHT

After the men in white appeared in the early 1980s, one decade later black silhouettes cropped up on Parisian walls, sometimes mixing with Jérôme Mesnager's figures. These men in raincoats, tightrope walkers, cyclists, simple passers-by chasing a red balloon, people carrying an umbrella or passengers on a paper boat can be found in the streets of the 20ᵗʰ arrondissement, the home district of their creator, **NEMO**.

Local residents and Parisians in general are familiar with the works of this self-taught artist, but so are the people of Tokyo and Lisbon. Several of his murals feature on the route. One huge work adorns the facade of a hundred-year-old block of flats seven storeys high at <u>146, Boulevard de Ménilmontant,</u> *which the local children use as a landmark for saying where they live. Another mural can be found at* <u>38, Rue de Ménilmontant.</u>

NEMO's graphic art universe has its origins in the comic strip 'Little Nemo in Slumberland': the artist used to tell his son about the adventures of McCay's hero and then regularly added works along the boy's route to school. But his street art is also a reference to the film The Red Balloon by Albert Lamorisse, which was filmed in 1956 in the streets of this neighbourhood.

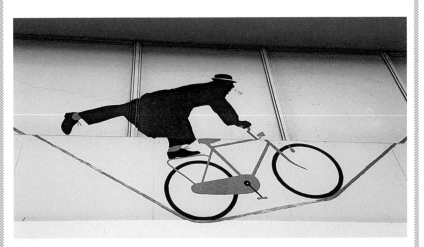

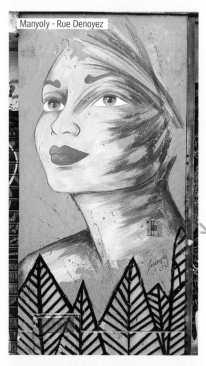

Manyoly - Rue Denoyez

Why is so much street art to be found high up? The municipality of Paris is responsible for removing street artists' creations that are less than four metres from the ground. Above that, it's a job for the residents!

The walk ends in Rue Dénoyez 16, a real feast of spontaneous street art, with new works regularly appearing. If you want to continue further, you could try Rue Lemon and Rue de la Fontaine-au-Roi, where various murals have appeared.

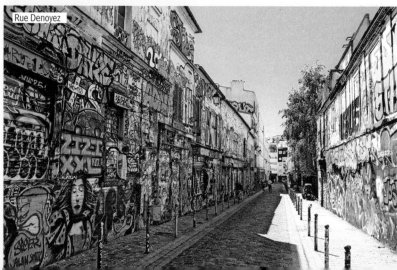

Rue Denoyez

GOOD TO KNOW

In the summer of 2019, many of the artists' studios in **Rue Dénoyez** made way for social housing and a crèche. These studios, which did not have very secure occupancy agreements, were run by four associations: Alternation, La Maison de la Plage, Traces, and Friches et Nous la Paix. Only the last of these four still has a studio: number 16 in this street is not under threat from building work and is still a place where people can meet, with a gallery open to the public.

But don't worry, the building work only applies to the side of the street with even numbers and graffiti artists can still get creative on the walls opposite, or on the metal shopfront shutters.

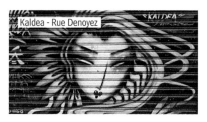
Kaldea - Rue Denoyez

USEFUL ADDRESSES

BARS AND RESTAURANTS

① LE BARBOUQUIN
For a really great concept
1 Rue Dénoyez, 75020 Paris • +33 (0)9-84321321
Mon-Fri 09:00-19:00, Sat-Sun 10:00-19:00

② CAFÉ LA LAVERIE
Nice pavement cafe with retro look
1 Rue Sorbier, 75020 Paris • +33 (0)1-43663964
Mon-Fri 09:00-2:00, Sat-Sun 10:00-2:00

③ LES MÉSANGES
For its wall and more!
82 Rue de la Mare, 75020 Paris • +33 (0)9-70385082
Mon-Fri 08:00-02:00, Sat 09:00-02:00, Sun 10:00-06:00
www.lesmesanges.fr

BOOKSHOPS

④ L'ATELIER
For its independent spirit
2 bis Rue du Jourdain, 75020 Paris • +33 (0)1-43580026
Tue-Sat 10:00-20:00, Sun 10:30-13:30

⑤ LE MONTE-EN-L'AIR
For its gallery-cum-bookshop concept
71 Rue de Ménilmontant / 2 Rue de la Mare
75020 Paris • +33 (0)1-40330454
Every day 13:00-20:00 (Sat 10:00-20:00)
montenlair.wordpress.com

ART GALLERIES

⑥ LES TEMPS DONNÉS
For its studio/gallery/wine cellar concept
16 Rue des Envierges, 75020 Paris • +33 (0)6-14890505 Wed-Sun 14:00-19:00

⑦ L'ESPACE OBERKAMPF
New exhibition space
140 Rue Oberkampf • +33 (0)1-48070587
Wed-Sat 14:00-18:30
espace-oberkampf.fr

LOCAL ATTRACTIONS

⑧ BELLEVILLE PARK
47 Rue des Couronnes, 75020 Paris

M.U.R. OBERKAMPF

A double advertising board dedicated to becoming a must-see street art site in Paris? That is M.U.R Oberkampf.

Mono Gonzalez

Jo Di Bona

Ogre

The story of M.U.R (Modular, Urban and Responsive) started in 2000 with the work of Thomas Schmitt, aka Thom Thom. His art consisted of using a knife to cut away the layers of paper that had accumulated on advertising boards — including the two boards at the intersection of Rue Oberkampf and Rue Saint-Maur — and making use of the resulting shapes. Through this, he came into contact with Jean Faucheur and invited him to stick up a series of artworks.

Various other encounters led to the creation of a temporary collective. One night in 2002, it took action in the streets of the 11th arrondissement, replacing the advertising posters on 60 boards measuring 4 x 3 metres with original collages of the same dimensions. The aim was to unite artists working with paper and street artists and let them create art on a large scale.

In 2003, the double advertising board was removed and cladding installed around two spaces: the larger space was reserved for advertising posters while the smaller was accompanied by the message "Advice to artists: this panel is reserved for you to allow to give free rein to your imagination". Thom Thom turned this on its head with his message, "Space for autistic people". That same year, the group filed its articles of association (the city's art committee gave its approval in 2005). The team, with Jean Faucheur as its chair and assisted by Thom Thom as the secretary plus Malitte Matta and Bob Jeudy, brought together artists and enthusiastic art collectors and came up

with scale models to get things moving in the town hall for the 11th arrondissement.

M.U.R. was officially inaugurated in 2007 with the exhibition of an artwork by Gérard Zlotykamien. While the association got through its first year as an official entity without any grants, they started to flood in three years later and before long it had permanent funding. The M.U.R. wall soon shook off its cladding and acquired the appearance it has today. The artists can work inside the frame but they can also express themselves outside those borders.

All artists are paid for their work. Starting three years ago, there have been performances every second and fourth weekend in the month that attract the attention of local residents and graffiti photographers. The association aims for a programme in which at least half the artists are French, and that includes women and duos. All the artists are chosen based on their experience and skills in working on large surfaces.

The M.U.R. initiative has now spawned versions in the French towns of Bordeaux, Saint-Étienne, Épinal and Pérols. These towns have adopted the association's stance, letting artists get creative in urban spaces while observing certain rules, such as one single wall to ensure a permanent meeting point, and payment of the artists. Above all, the street art should replace advertising so that passers-by are given the opportunity to discover an artwork.

Halfstudio

David Petroni

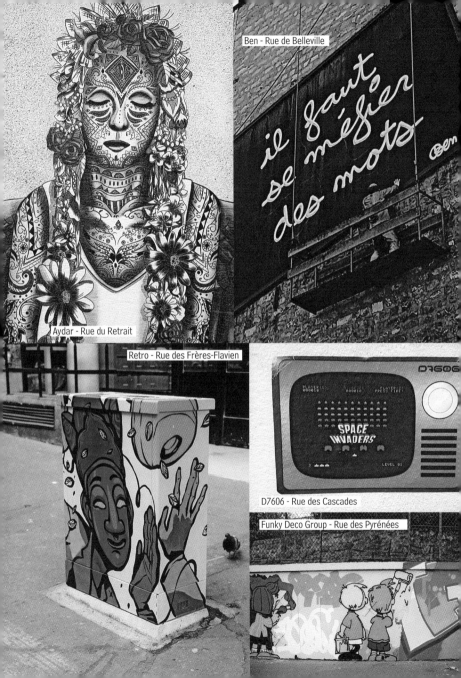

Aydar - Rue du Retrait

Ben - Rue de Belleville

il faut se méfier des mots

Retro - Rue des Frères-Flavien

D7606 - Rue des Cascades

Funky Deco Group - Rue des Pyrénées

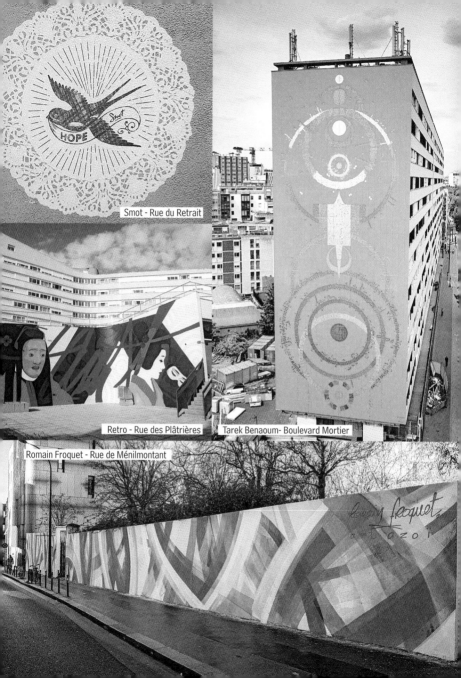

Smot - Rue du Retrait

Retro - Rue des Plâtrières

Tarek Benaoum- Boulevard Mortier

Romain Froquet - Rue de Ménilmontant

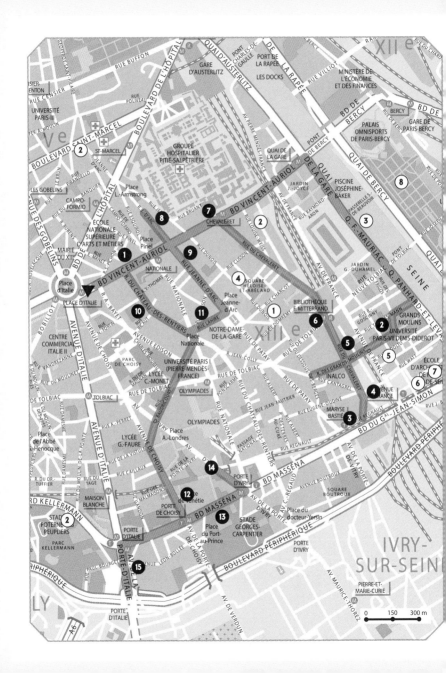

THE 13th ARRONDISSEMENT,
size XXL!

An XXL walk of at least four hours across the 13th arrondissement, introducing you to some very large-scale works by international artists in a range of techniques. The programme includes murals by Shepard Fairey, C215, Int and others, the anamorphic art of Zag & Sìa, Vhils' portraits created using explosives and a mosaic by Invader. A neighbourhood known for its street art thanks to the combined efforts of the 13th arrondissement municipality, social housing associations and the galleries Mathgoth and Itinerrance.

FOLLOW THE GUIDE

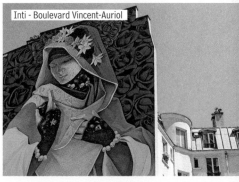

Inti - Boulevard Vincent-Auriol

To explore this route from a different perspective (and spare your legs), take the overground metro (line 6 towards Nation) from Place d'Italie to the Quai-de-la-Gare station. This will give you an opportunity to spot and admire works by D*Face, C215,

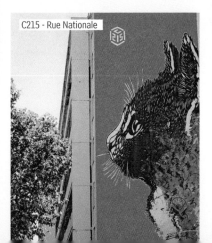

C215 - Rue Nationale

Shepard Fairey, Seth, Faile, David de la Mano, Inti, Hush, Bom K and Invader spread along Boulevard Vincent-Auriol 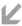. Another solution is to hire a Vélib' bike so you don't miss any of the murals created by artists along the metro line.

When you exit the metro, take <u>Quai Panhard-et-Levassor</u> on your right and follow the Seine until you get to <u>Rue Thomas-Mann</u>. Take the first street on the left, after a few metres, where the skeleton of a cat standing upright on its hind legs, signed by the Belgian artist Roa ❷, invites you to take the bridge over the Grands-Moulins-Abbé-

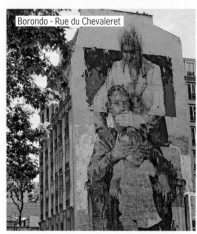

Borondo - Rue du Chevaleret

Roa - Rue Marguerite-Duras

Pierre gardens. Then take <u>Rue des Grands-Moulins</u> to get onto <u>Rue du Chevaleret</u>, where you will find Reka ❸, Tristan Eaton ❹, Zag & Sìa ❺ and Borondo ❻.

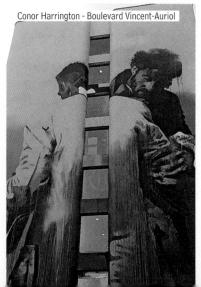

Conor Harrington - Boulevard Vincent-Auriol

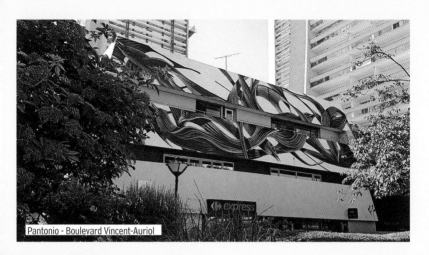

Pantonio - Boulevard Vincent-Auriol

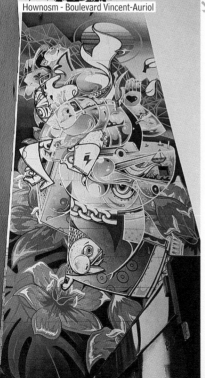

Hownosm - Boulevard Vincent-Auriol

You return to <u>Boulevard Vincent-Auriol</u> ❼, where you can spot works by Invader, David de la Mano, Maye, Cryptik, Pantonio, Conor Harrington and Hownosm.

WHEN THE CITY SLEEPS

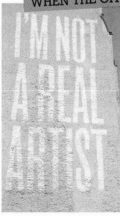

Spy's text in Rue du Chevaleret, I'm not a real artist, is written in luminous paint and appears as night falls. This Spanish artist, who has been active in the streets since the 1980s, likes playing with words.

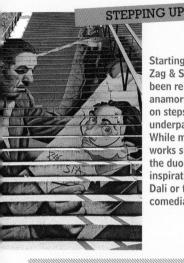

STEPPING UP

Starting in 2012, Zag & Sìa have been reinventing anamorphic art on steps or in underpasses. While most of their works show Sìa, the duo also draw inspiration from Dali or the French comedian Coluche.

↘ Feel free to explore the streets turning off the boulevard. Seth, Jana und JS ❽, Shepard Fairey and C215 ❾ can all be found in Rue Jeanne-d'Arc. Continue on to Rue du Château des-Rentiers ❿ to discover the distinctive art of Vhils, and stroll down Rue Lahire ⓫ for Inti's colourful mural.

NOT TO BE MISSED!

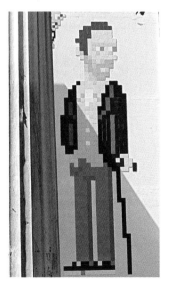

Since the 2000s, **Invader** (who calls himself an Unidentified Living Artist) has been brightening up walls with his UFOs, little pixellated mosaics conceived as a reference to the video game Space Invaders. In July 2016, at the invitation of Mehdi Ben Cheikh (of the gallery Itinerrance) and Jérôme Coumet (mayor of the 13th arrondissement), he staged an event in which he created a massive artwork on the wall of Pitié-Salpêtrière hospital, Boulevard Vincent-Auriol, in the space of one night.
Helped by his assistant, he produced a picture of the eponymous star of the TV series Doctor House. This 1205th artwork extending to a height of 10 metres pays homage to the medical staff at the hospital.

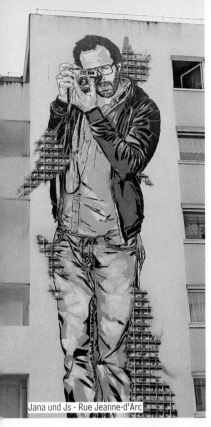

Jana und Js - Rue Jeanne-d'Arc

VIHILS IS DYNAMITE

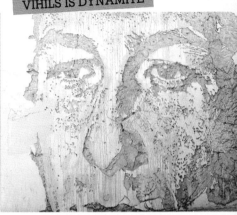

Born in 1987, Alexandre Farto aka Vhils uses a chisel and dynamite! This Portuguese artist, who was spotted by Banksy's agent at the Cans Festival London in 2008, carves out portraits of iconic individuals in walls destined for demolition in various districts.

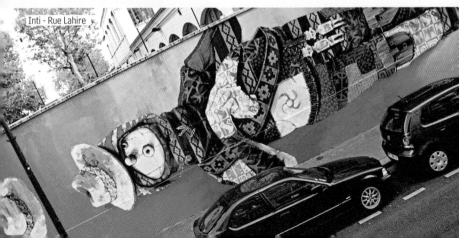

Inti - Rue Lahire

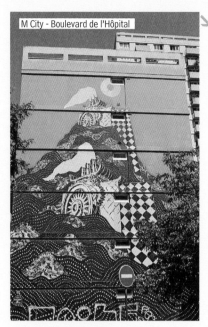

M City - Boulevard de l'Hôpital

Walk on to <u>Place de Vénétie</u> **12** to view Stew's heron and the artwork by Pantonio. To finish this walk, head down <u>Boulevard Masséna</u> **13** to catch the mural by Ethos, <u>Avenue d'Ivry</u> **14** for Okuda San Miguel's take on the Mona Lisa and <u>Avenue d'Italie</u> **15** to find Sainer.

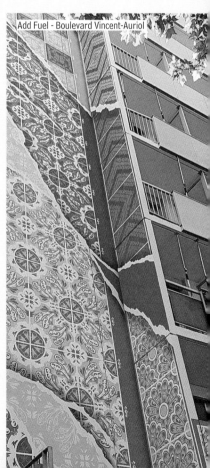

Add Fuel - Boulevard Vincent-Auriol

FROM CHILE TO PARIS

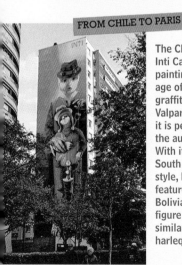

The Chilean artist Inti Castro started painting at the age of 13 in the graffiti paradise of Valparaíso, where it is permitted by the authorities. With its typically South American style, his art often features Kusillo, a Bolivian carnival figure with similarities to a harlequin.

ARTIST IN THE SPOTLIGHT

Shepard Fairey (OBEY) first garnered attention with his series of André the Giant stickers, before making a name for himself internationally during the US presidential campaign in 2008. This activist artist financed, produced and distributed more than 300,000 stickers and 500,000 posters of an image of Obama above the word HOPE, hugely boosting the Democrat candidate's visibility among the general public in the run-up to the election.

As many as four works by the artist can be seen in the arrondissement: one dating from 2012 (Rue Jeanne-d'Arc) and three others created in June 2016 (one of which graces the facade of art gallery Itinerrance). The mural Liberté, Égalité, Fraternité, based on an older

illustration, pays homage to the victims of the terrorist attacks in Paris in November 2015, delivering a message of peace, harmony and tolerance. Delicate Balance recalls the artist's work (a globe suspended under the Eiffel Tower) created for the climate change conference COP21: consisting entirely of blue and turquoise (symbolising air and water), this mural seeks to raise awareness about the need to protect the environment. These colossal works were created by a team using stencils cut to fit the walls that support the artworks!

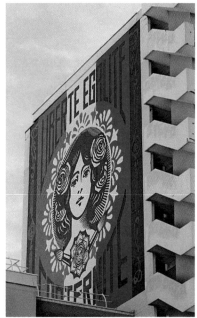

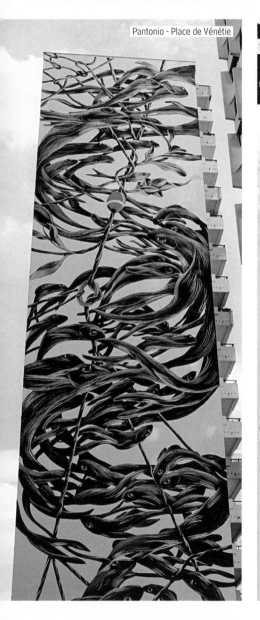

Pantonio - Place de Vénétie

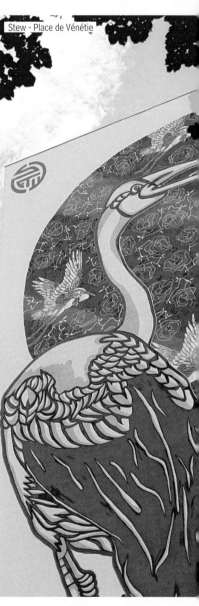

Stew - Place de Vénétie

GOOD TO KNOW

Every year, **Les Frigos** opens its doors to people in the area at the end of May, with exhibitions and workshops (www.les-frigosapld91.com). The spiral staircase should not be missed! When it is not open to the public, go to the car park where you will be bound to see an artist at work.Located on the Port de la Gare, near the Passerelle Simone-de-Beauvoir, **M.U.R. XIII** is an extension of the M.U.R. Oberkampf initiative. The space is managed by the M.U.R. XIII association (www.lemur13.com), offering passers-by the pleasure of a new work of street art every three weeks. Each performance results in an edition of silk-screen prints that help fund the project (which is subsidised by the Paris town hall) and pay the artists. This route is accessible for everyone, thanks to Jocelyn who runs the Access Trip blog dedicated to people with disabilities (accesstrip.org).

USEFUL ADDRESSES

BARS AND RESTAURANTS

① TWENTY PEAS
For its fresh produce and stylish interior
30 Rue de Domrémy, 75013 Paris •
+33 (0)1-43432618
Mon-Fri 12:00-15:00
www.twentypeas.fr

② LA FELICITÀ
A food market with an Italian flavour
5 Parvis Alan-Turing, 75013 Paris
See www.lafelicita.fr for opening hours

③ LE BATEAU-PHARE
A new lease of life for this legendary place (and its pavement cafe)
11 Quai Francois-Mauriac, 75013 Paris •
+33 (0)6-89863503 Mon-Sun 11:00-2:00

BOOKSHOP

④ LE CHAT PITRE
A treasure trove for kids
22 bis Rue Duchefdelaville, 75013 Paris •
+33 (0)1-44245220
Mon 15:00-19:30, Tue-Sat 10:30-19:30

ART GALLERIES

⑤ GALERIE MATHGOTH
For its awesome programme
34 Rue Hélène-Brion, 75013 Paris •
+33 (0)6-63014150 Wed-Sat 14:00-19:00 or
by appointment www.mathgoth.fr

⑥ GALERIE ITINERRANCE
For its awesome programme too!
24 bis Boulevard du Général-Jean-Simon,
75013 Paris • +33 (0)1-44064539 •
Wed-Sat 12:00-19:00
itinerrance.fr

⑦ LE LAVO MATIK
For the diversity of its art and for its bookshop
20 Boulevard du Général-Jean-Simon, 75013 Paris
• +33 (0)1-45836992 • Tue-Sat 12:00-19:00

LOCAL ATTRACTIONS

⑧ BERCY PARK
128 Quai de Bercy, 75012 Paris

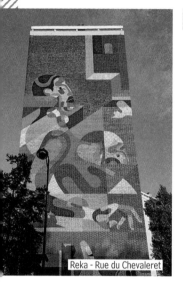
Reka - Rue du Chevaleret

Zloty – Rue du Dessous-des-Berges

MONUMENTAL WORKS... HERE'S HOW

This profusion of colossal works is unparalleled in Paris. Gautier and Mathilde Jourdain (who founded the gallery MathGoth) tell us what goes on behind the scenes when creating these giant works, an operation that requires specific technical expertise and significant logistics.

Friends since childhood, Mathilde and Gautier (Math and Goth) have been urban art aficionados for a long time. An initial trigger was the poster 'La Ruée vers l'Art' by La Speedy Graphito in 1986. Then in the early 1990s they became friends with Jean Faucheur, who introduced them to the technical aspects of urban art and its history.

Their first major project dates from 2008 when they united 400 artists from all over the world, giving each complete freedom to create whatever they wanted. In 2010, they decided to set up their gallery, initially online (renting space in Paris for their exhibitions), then three years later on Rue Hélène-Brion in the 13ᵗʰ arrondissement. A reconnaissance beforehand is essential when creating monumental works. Once they have found the ideal wall, MathGoth contact Jérôme Coumet, mayor of the 13ᵗʰ arrondissement and a great connoisseur of street art. After this step, they meet with the owner of the site, often a social housing organisation. Once the project has got the go-ahead, the residents of the apartment block are consulted about the choice of artists. The residents can also vote for one or other project on the town hall's site. Often, a mural is created in a neighbourhood with the aim of improving

Rodriguez Gerada - Rue Nationale

the living environment, promoting art and culture, or creating an open-air museum.

It also serves as an occasion to meet and interact with the artist, which makes it a genuine exercise in cultural democracy.

Then there is the logistical aspect, in particular the question of where to place the cherry-picker that lets the artist do their work safely. All these steps require up to a year of preparation and the vagaries of the weather (bad or otherwise) do not always make it possible to have a parallel exhibition in the gallery.

The first work to be implemented in this way was produced in Vitry. Since then, the experiment was repeated in Paris, with David Walker in June 2015, and Nancy, with Jef Aérosol in June 2016. In 2017, the gallery turned the spotlight on the Portuguese artist Bordalo II, giving him a wall in Rue Chevaleret. The highlight for Gautier was the opportunity to invite Gérard Zlotykamien, a major artist who has been operating in the streets since 1963, to produce a monumental work. The artwork was completed in October 2019. As for the next artists to be scheduled, you will have to come to the district to find out who they are!

Herakut - Rue René-Goscinny

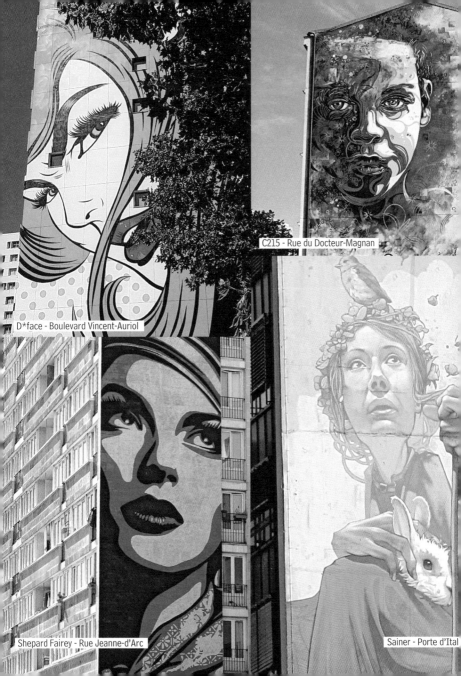

C215 - Rue du Docteur-Magnan

D*face - Boulevard Vincent-Auriol

Shepard Fairey - Rue Jeanne-d'Arc

Sainer - Porte d'Ital

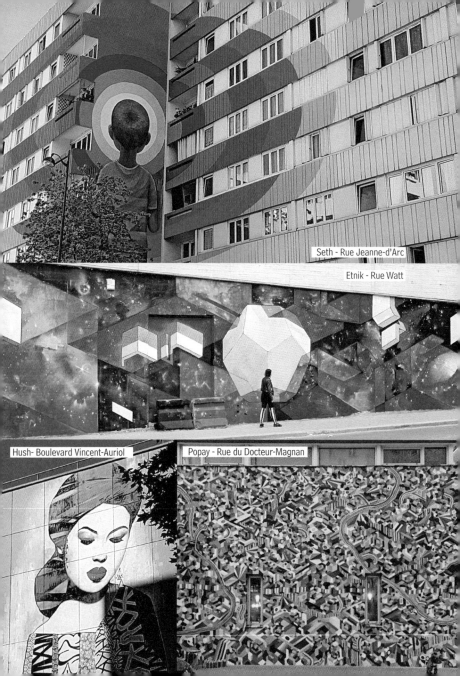

Seth - Rue Jeanne-d'Arc

Etnik - Rue Watt

Hush- Boulevard Vincent-Auriol

Popay - Rue du Docteur-Magnan

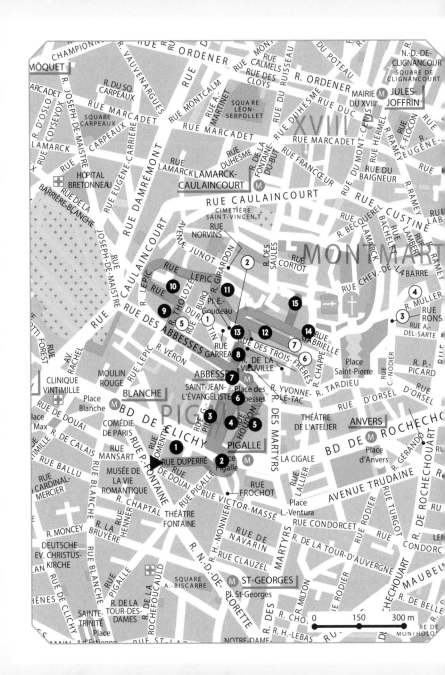

MONTMARTRE'S
artistic revival

This ninety-minute walk through the heart of Pigalle and Montmartre lets you see this tourist spot from a different perspective! The favourite haunt in the past of Pissaro, Toulouse-Lautrec, Van Gogh and Picasso (before they moved on to Montparnasse), nowadays the streets are the scene of an artistic revival thanks to urban art and its many representatives of all generations.

FOLLOW THE GUIDE

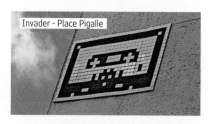
Invader - Place Pigalle

The walk starts in <u>Rue Duperré</u> ❶, home to Paris's coolest basketball court. Not far from here, <u>Place Pigalle</u> ❷ takes you back in time (or perhaps not) with Invader's cassette recorder.
Cross the square and continue down <u>Villa de Guelma</u> ❸ on your left, where you will come across a Space Invader and Gregos's first mask. The streets running parallel, such as <u>Rue André-Antoine</u> ❹, are also worth a look. Continue along <u>Rue Houdon</u> ❺, where Miss.Tic and Mr Lolo have adorned the shop front of no. 19 (Marchand d'Habits). Further along on the left, Le CyKlop has taken over the bollards down <u>Rue Piemontesi</u> ❻ to pay homage to the artists who made this district famous.

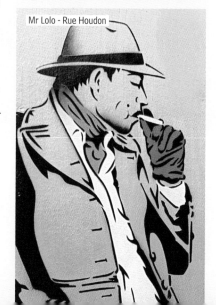
Mr Lolo - Rue Houdon

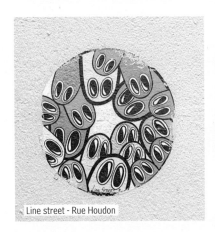

Line street - Rue Houdon

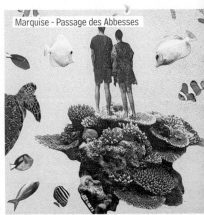

Marquise - Passage des Abbesses

 When you get to <u>Place des Abbesses</u>, turn left so as not to miss a work by Olivia de Bona ❼ at the point where <u>Rue des Abbesses</u> and <u>Rue André-Antoine</u> meet. Take a detour down <u>Passage des Abbesses</u> ❽ (opposite) to spot works by various artists (including Liz Art Berlin, Gregos and Jimzina).

STORY TIME

Olivia de Bona, one of the artists of the 9ᵉ Concept collective (which includes Lapinthur and Romain Froquet), is superb at reinventing the children's story illustration. Her dreamlike universe with its otherworldly atmosphere is highly sensual.

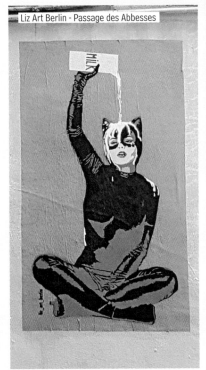

Liz Art Berlin - Passage des Abbesses

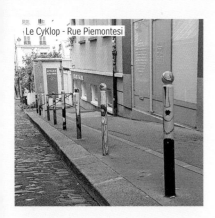

Le CyKlop - Rue Piemontesi

ILÉA'S CHILDREN

You will find his works in the 18th arrondissement, the district where he found a home a number of years ago when he fled the war in the Ivory Coast. You cannot fail to be moved by his art when you come across one of his portraits of children which the artist sees as an ode to life.

NOT TO BE MISSED!

Just off this route, near Place de Clichy, Rue Biot (off the map) houses the open-air museum of Jef Aérosol.

This music lover and former English teacher started his career creating stencils in the 1980s and soon made a name for himself alongside other artists such as Miss.Tic, Blek le Rat and Epsylon. His speciality is portraits.

Legends of music such as Bob Dylan, Serge Gainsbourg and John Lennon started to appear on walls, as well as cinema icons and anonymous individuals. They include the Sitting Kid, a solitary little boy huddled up. You will come across him not only here and in Butte-aux-Cailles but also abroad in London and New York, and even on the Great Wall of China. Whether in the streets or in galleries, Jef's portraits always feature a red arrow and his signature.

Coming back out of the passageway, turn right onto Rue des Abbesses and continue until <u>Rue Tholozé</u> ❾, where the walls — especially in the vicinity of the gallery Akiza — have been taken over by collages and stencils.

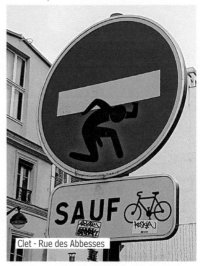

Clet - Rue des Abbesses

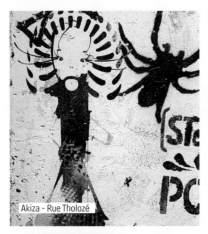

Akiza - Rue Tholozé

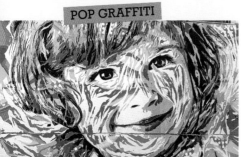

POP GRAFFITI

Jo Di Bona started as a graffiti artist alongside Nestor & Lek (team VF) in the early 1990s. He went on to mix collage and graffiti to create what he calls 'pop graffiti'. His brightly coloured works add a sense of movement to Paris's walls.

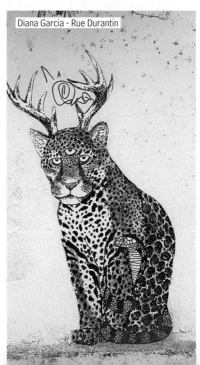

Diana Garcia - Rue Durantin

ARTIST IN THE SPOTLIGHT

Gregos grew up in the banlieues, the working-class suburbs north of Paris. In the late 1980s, he became involved in the tagging and graffiti scene. After spending time in Athens, he experimented with sculpture and the technique of moulding. He took up painting in the decade that followed. In 2006, back in Paris after extensive travels, he returned to his first love: street art.

Gregos sculpts his own face in 3D using a very specific technique, then paints it and sticks it up in the city's streets, particularly in Montmartre where he is now based. His self-portraits with their vivid colours and varied expressions attract the attention of passers-by. The artist's image on villa de Guelma is even sticking its tongue out at us! These moulded masks made of plaster, bronze, crystal or even chrome pop up out of the city's

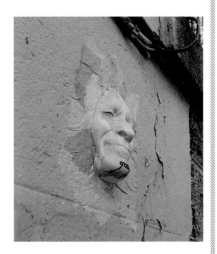

walls everywhere. There are over a thousand of them, mainly in France but also in Berlin, Tokyo, Los Angeles, London, New York and so on.

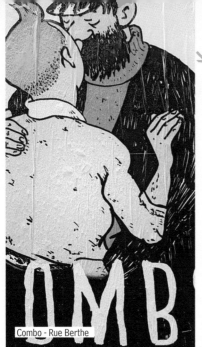

Combo - Rue Berthe

A little further along, turn left onto <u>rue Durantin</u> ⑩ where you will discover first a work by Oji on the facade of Le Petit Moulin restaurant, followed by various collages and stencils along the street, such as this one by Miss.Tic.

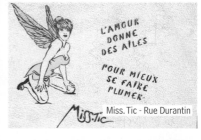

Miss.Tic - Rue Durantin

STREET DOLL

The art by YoSHii & Akiza is easy to recognise: their stencils show a doll with a body that changes, a majestic figure evolving in a rather sombre universe. You can meet the two artists in their art gallery in Montmartre.

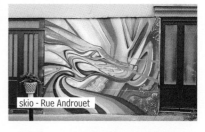

skio - Rue Androuet

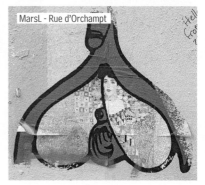

MarsL - Rue d'Orchampt

LE CYKLOP

When did you start working in the streets and why?

I started painting Parisian bollards in 2007. I wanted to break free of the wall and I appropriated this shape that reminded me of a person. Urban art is a contextual form of art: you use the street and its space as a material to help create meaning. Ernest Pignon-Ernest, for example, doesn't want his drawings to appear 'exhibited' in the street; he wants them to be physically inscribed. Taking possession of public space, with or without permission, is always a kind of game: you disrupt the established order, provoke a reaction, an encounter with the general public, whether they are local residents or on the other side of the world thanks to social media.

What is your main source of inspiration?

I create toys in which I draw inspiration from mythology, the story of Odysseus and Cyclops: the eye that drips is a crushed eye in Homer's epic. I've been inspired a lot by comic books, popular culture and history, as well as the Dada movement, Pop Art and Free Figuration. I'm interested in everything because you can find art in any object, in anything — it depends on how you look at your surroundings.

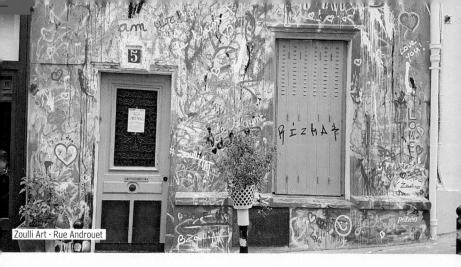
Zoulli Art - Rue Androuet

sh0ka - Rue Ravignan

↘ At the end of the road, turn right and continue the walk in the direction of <u>Rue d'Orchampt</u> ⓫ — it's a route worth the detour! Get onto <u>Rue Berthe</u> ⓬ (via <u>Rue Ravignan</u>), where you will find some amazing stuff, and the same goes for <u>Rue Androuet</u> ⓭.

Peace - Rue Ravignan

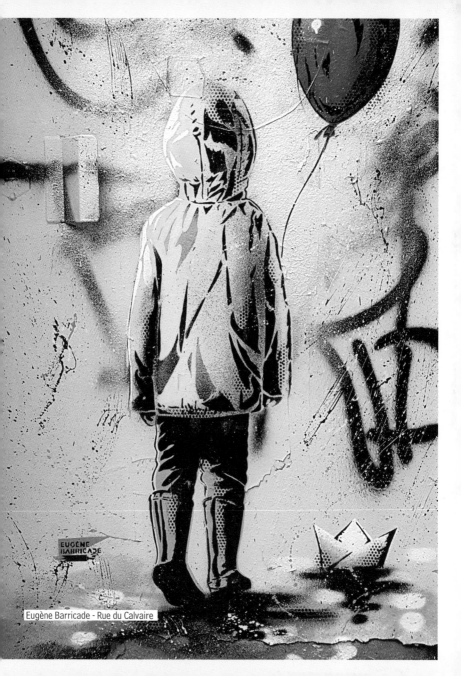

Eugène Barricade - Rue du Calvaire

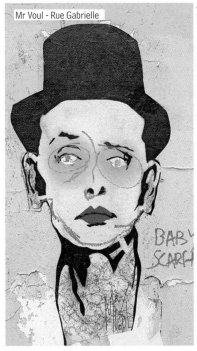

Mr Voul - Rue Gabrielle

Return to <u>Rue Berthe</u> and continue down <u>Rue Ravignan</u> and <u>Rue Gabrielle</u> ⓴, where you will come across the art of Mr VOuL and Aydar. Climb the <u>steps of Rue du Calvaire</u> ⓯, where various artists have been at work (for instance Codex Urbanus, Gregos and Le Mouvement). Finally, you will arrive at <u>Place du Tertre</u>, where you can enjoy a drink at a pavement cafe.

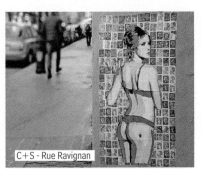

C+S - Rue Ravignan

MONSTERS LET FREE

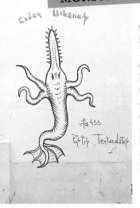

Codex Urbanus, born in Paris in 1974, is bringing enchantment back to the city with his drawings of imaginary creatures inspired by medieval bestiaries. He is particularly active in Montmartre.

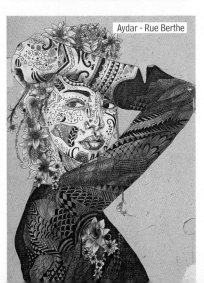

Aydar - Rue Berthe

GOOD TO KNOW

The museum **Art 42**, which was launched during the 2016 edition of the Nuit Blanche night-time arts festival (and is not a real museum), is definitely worth a visit! It is dedicated to street art and can be found on the premises of École 42, the IT college founded by Xavier Niel. In a space of more than 4,000 m^2, the urban art aficionado Nicolas Laugero Lasserre's collection consists of more than 150 artworks (murals and installations) by about fifty artists, including Dran, Romain Froquet, Shepard Fairey, Banksy, Invader and Monkey Bird.

Admission free on reservation via www.art42.fr, every other Tuesday from 18:00 to 21:00.
96 Boulevard Bessières, 75017 Paris

USEFUL ADDRESSES

BARS AND RESTAURANTS

① GUILO GUILO
For an awesome Japanese experience
8 Rue Garreau, 75018 Paris · +33 (0)1-42542392
Tue-Sat 19:00-23:00, reservation definitely recommended

② LE RELAIS DE LA BUTTE
For its amazing view
12 Rue Ravignan, 75018 Paris ·
+33 (0)1-42239464
Every day, 12:00-24:00

③ LE PETIT BLEU
Treat your taste buds to a great couscous or tajine
23 Rue Muller, 75018 Paris · +33 (0)1-42592701
Mon 19:00-24:00, Tue-Sun 12:00-15:30/19:00-24:00

④ CHEZ PROUT
Stop for a fantastic gastronomic experience in stylish interior
14 Rue Muller, 75018 Paris · +33 (0)9-83699503
Mon 19:30-22:00, Tue 19:30-22:30, Wed-Thu 12:00-14:00/19:30-22:30, Fri 12:00-14:00/19:30-23:00, Sun 12:00-15:00/19:30-22:00

ART GALLERIES

⑤ AKIZA GALLERY
For the artists who run the gallery
3 Rue Tholozé, 75018 Paris · +33 (0)6-86268088
Mon & Thu 14:30-20:00, Sat-Sun 12:30-19:00
www.akizastore.com

⑥ STREETARTALLEY
For their energy and the exterior walls
2-8 Rue Androuet, 75018 Paris
Tue-Sat 14:00-19:30 · www.streetartalley.paris

SHOPPING

⑦ PAUL ART & DESIGN
For unusual souvenirs
29 Rue Berthe, 75018 Paris · +33 (0)7-68972691
Tue 11:00-14:30/17:30-20:30, Wed-Mon 11:00-20:30
www.paulartetdesign.com

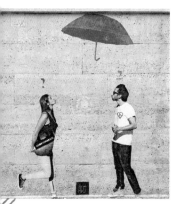

LE MOUVEMENT

Collective, participatory street art? Le Mouvement has been creating subtly engaged artworks in Parisian streets since 2013 with its black-and-white collages with a touch of colour.

Founded by Riks, Romano and Tiez, three artists working in complementary areas (the plastic arts, painting, graffiti art, photography), Le Mouvement puts up its coloured collages, telling the story of a romantic encounter, throughout the city.

The principle works as follows. They make a full-length portrait of an anonymous couple (local residents, members of an association, shopkeepers) beneath an umbrella (an everyday object that encourages proximity). There are four scenes showing four stages: the chance encounter between two strangers; the surprise attraction (looking at one another); the pleasurable interaction (the smile); and the farewell under the umbrella.

Le Mouvement takes the participatory aspect to extremes, inviting the actors for a day to lend a hand in cutting out and sticking up the results of the photography session. These participants even created a stencil in the form of an umbrella with the collective's name underneath for signing the artworks.

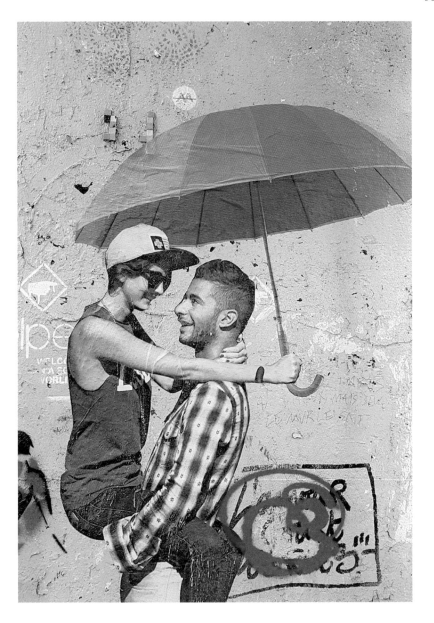

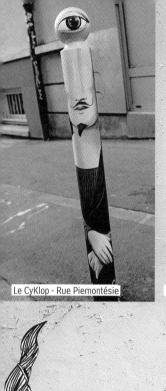

Le CyKlop - Rue Piemontésie

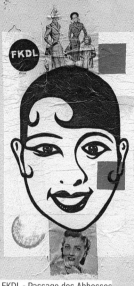

FKDL - Passage des Abbesses

Qwert - Rue d'Orchampt

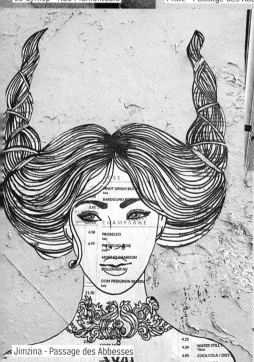

Jimzina - Passage des Abbesses

Bea Py - Rue Houdon

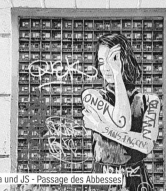

Jana und JS - Passage des Abbesses

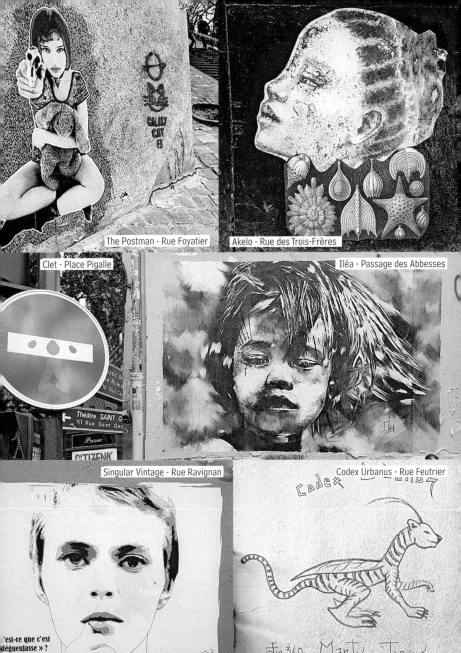

The Postman - Rue Foyatier

Akelo - Rue des Trois-Frères

Clet - Place Pigalle

Iléa - Passage des Abbesses

Singular Vintage - Rue Ravignan

Codex Urbanus - Rue Feutrier

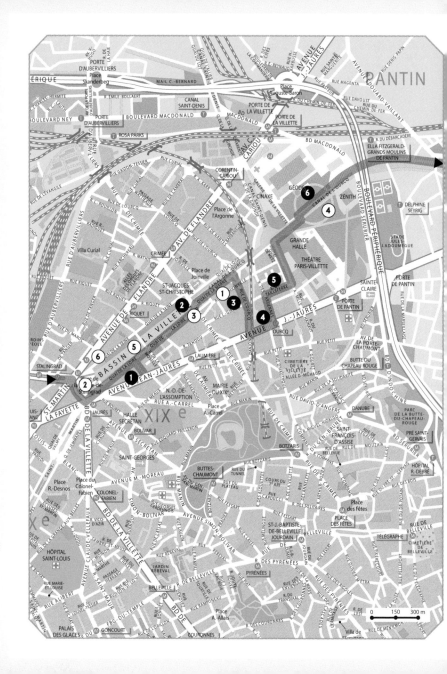

ROM STALINGRAD
to Pantin

Hip-hop culture took hold in the Stalingrad neighbourhood in the 1980s, especially in the undeveloped terrain of La Chapelle, where the first generation of artists appropriated the walls and metro. This walk of about one and a half hours will take you from artwork to artwork as far as Pantin, while enjoying the peaceful setting of Villette lake and Ourcq canal (a route that can easily by done by bike). During the Summer on the Canal festival, you can follow the watercourse as far as Bondy municipality to discover more murals by such artists as Marko 93, Joachim Romain and Fin DAC.

FOLLOW THE GUIDE

Starting at Stalingrad station (metro lines 2, 5 or 7), walk along the banks of Villette lake on the Quai de la Loire side. Turn down <u>Rue Henri-Noguères</u> to see some artists' works.

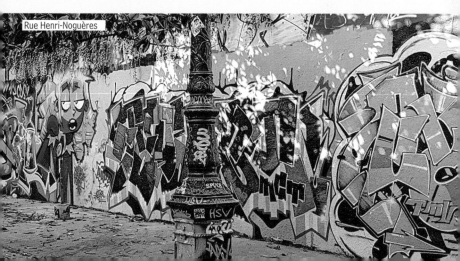

Rue Henri-Noguères

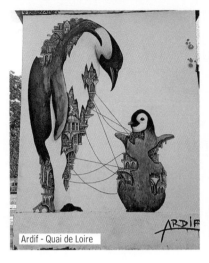
Ardif - Quai de Loire

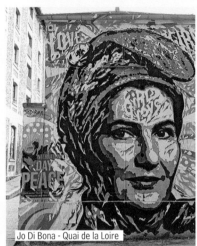
Jo Di Bona - Quai de la Loire

As you continue along <u>Quai de la Loire</u>, stop at coffee shop Pavillon des Canaux (no. 39) ❷, which is unusual not just for its lively facade but also for its zany decor. Even better, savour a coffee while you admire the place. Watch out for artworks in the vicinity of the Pavillon that were created for the Festiwall 2019 by such renowned artists as Ardif, Jo Di Bona, Joachim Romain, JBC and Andrea Ravo Mattoni.

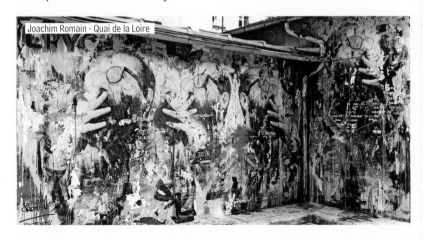
Joachim Romain - Quai de la Loire

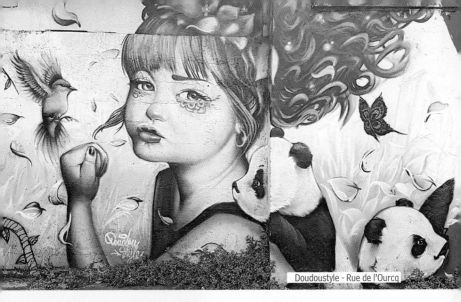

Doudoustyle - Rue de l'Ourcq

Continue along <u>Quai de la Marne</u>, then turn right onto <u>Rue de l'Ourcq</u> ❸ for a rewarding detour.

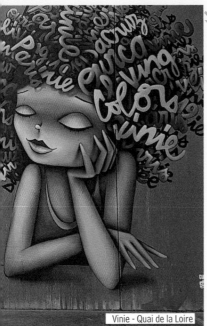

Vinie - Quai de la Loire

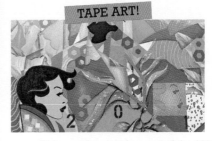

TAPE ART!

This mural, created as part of the 2015 Ourcq Living Colors festival, is signed by FKDL and Gabriel Specter. Besides his outdoor work, FKDL specialises in tape art, following in the footsteps of Gil Joseph Wolman in the 1960s.

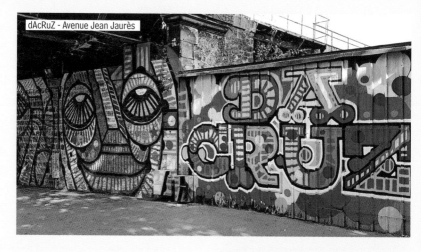
dAcRuZ - Avenue Jean Jaurès

⬂ You will discover various murals, including by dAcRuZ and other artists such as Marko93 and FKDL, bringing vibrant colours to the neighbourhood.

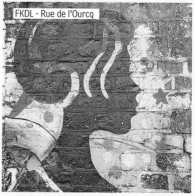
FKDL - Rue de l'Ourcq

HYPNOTIC

Originally from the South of France, KAN is a member of the DMV (Da Mental Vaporz) collective, which includes such big names in the graffiti scene as Gris1, DRan, Brusk, Blo, Bom.K, Iso, Jaw and SOwat. He uses a technique that is rare in street art: street pointillism, a mixture of pixellated art and screen printing.

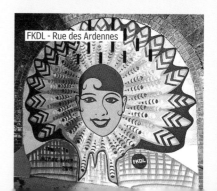
FKDL - Rue des Ardennes

NOT TO BE MISSED!

In the late 1980s, **Marko93** started expressing himself on the walls of Saint-Denis, the town he grew up in. He explored various techniques in the decade that followed, giving preference to calligraphy and experimenting with painting the bodies of dancers from Rio to Hong Kong.

In the early 2000s, he started working with light painting. In 2011, he was the initiator of group performance MonuLight in the square in front of the Basilica of Saint-Denis.

Recently, animals have become a central theme in his work.

In 2019, he created his Chromatic Symphonies. This series of paintings done to music is a homage to the musical influences that have marked his career, with each canvas referring to a particular passage. On this route, you can find works by Marko93 in *Rue Germaine-Tailleferre* and *Rue de l'Ourcq*.

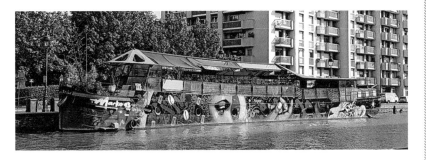

Get back onto <u>Rue des Ardennes</u> ❹. Then take the second street on the right, <u>Rue Germaine-Tailleferre</u> ❺, which is impressive for the quality of the murals on display, for example by dAcRuZ, Skio, Marko93, PEC and Louis Masaï. After you have finished exploring this street, turn left onto <u>Quai de la Garonne</u>, which becomes <u>Quai de Metz</u> and takes you back to Villette lake ❻. Cross to the other side of Ourcq canal to stroll along this pedestrian route that will take you to Pantin.

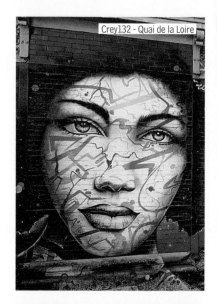
Crey132 - Quai de la Loire

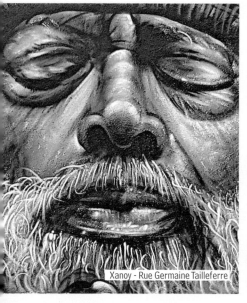
Xanoy - Rue Germaine Tailleferre

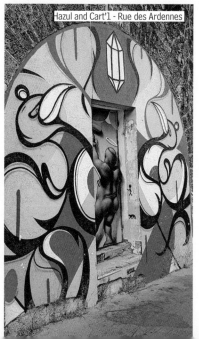
Hazul and Cart'1 - Rue des Ardennes

dAcRuZ, a self-taught French artist, grew up in Paris's 19th arrondissement before setting off for travels all over the world. His primitive style of graphic art, drawing on his contacts with ancient cultures, recalls the masks of pre-Colombian civilisations.

This artist's way with colour is very distinctive! In France, he started the Ourcq Living Colors festival in 2006 in Paris and he is actively involved in developing this event. In 2015, on the initiative of *ONG CARE*, dAcRuZ highlighted the impact of climate change on our habitat with a mural showing a flood in Latin America with some boats taking people to safety as water levels rise, while a man in a suit (a politician?) watches passively. This artwork can be seen in _Rue Germaine-Tailleferre_. In the 'Artworks moving into the street' project, the municipality of Paris selected eleven graffiti artists to produce street art in eleven of the city's arrondissements.

In 2018, a wall on a building 10 metres tall was transformed into a totem by dAcRuZ. You can see this work in _Rue des Périchaux_ in the 15th arrondissement. The artist is still very active in Paris's streets, and he will be in evidence on the route of the next edition of the Ourcq Living Colors festival.

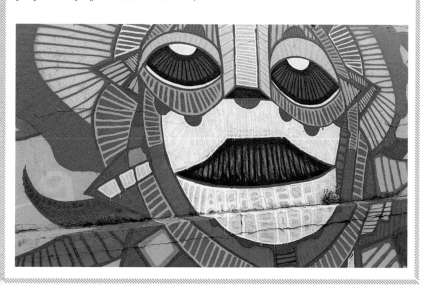

Who are you?
Jean-Baptiste Colin, alias JBC, painter and mural artist from Montreuil.

When did you start working in the streets and why?
I started in 2009. Initially, I did unauthorised collages at random as I wandered through the streets of Paris. My motivation is political as much as it's artistic. I want to get back to the posters of the May '68 uprising. Like for many street artists, over the years the format and techniques have evolved so that my work has become larger and less ephemeral.

What triggered you to start doing street art?
A trip to Berlin in 2007. I saw some great street art and when I got back to Paris, I realised there were also these works in my own city! I guess we are more aware of our surroundings when we're travelling.

What is your main source of inspiration?
Religious icons and classical painting. I like using them, appropriating and transforming them with my graphical codes from pop culture and ultimately, making them serve my purpose.

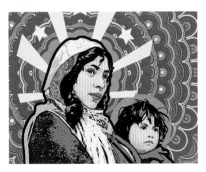

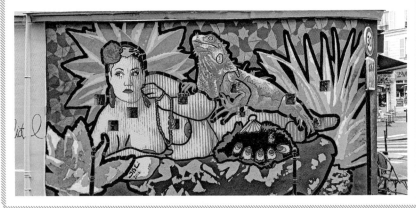

OM Pass the offices of BETC advertising agency (the old Magasins Généraux, the place to be for graffiti artists), then just before you get to Pantin town hall, head off to explore the area around the bridge and find street art. Walk along <u>Quai de l'Ourcq</u> in the vicinity of the town hall, admire the anti-parking stones that have been given a new look by Le CyKlop and spot the awesome artwork by Fin DAC (<u>21, Rue Delizy</u>)!

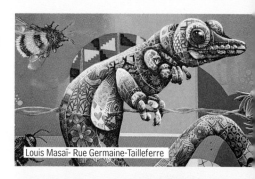

Louis Masaï- Rue Germaine-Tailleferre

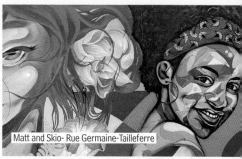

Matt and Skio- Rue Germaine-Tailleferre

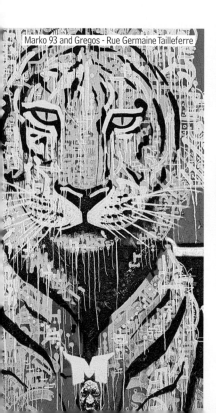

Marko 93 and Gregos - Rue Germaine Tailleferre

EYE ON STREET ART

Since 2007, Le CyKlop has been taking over street furniture intended to prevent parking and creating works inspired by Greek mythology or pop culture. An off-best approach to getting around prohibitions!

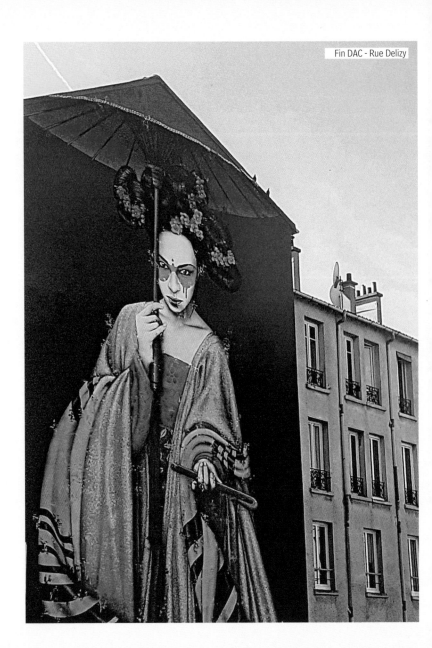

Fin DAC - Rue Delizy

GOOD TO KNOW

Explore the **district through its street art** (from Bobigny to Pantin, the length of the Ourcq canal) with artist Thom Thom as your guide: an original excursion through the heart of an urban area with constantly evolving graffiti art.

Register via the site www.tourisme93.com
Price: €19

In summer (July and August), you can admire the graffiti from the **shuttle service** running down the canal, an unusual viewpoint for not much money.

Leaves every 40 minutes from Villette lake
Price: €1 on Saturdays, €2 on Sundays

If you don't have sea legs, go to **AICV** (near Villette park on the banks of Ourcq canal) to hire a bike (open all year) and take the cycle route along the canal. Adult bike from €4 for 1 hour.

Arches, 38 bis Quai de la Marne, 75019 Paris
www.aicv.net

M 53 - Quai de la Loire

USEFUL ADDRESSES

BARS AND RESTAURANTS

① CAFÉ ODILON
For its attentive staff and the fresh produce
16 Quai de la Marne, 75019 Paris •
+33 (0)1-40361822 Tue-Sun 10:00-02:00

② LE ROTONDE STALINGRAD
Amazing dome and pleasant place to sit outside in summer
6-8 Place de la Bataille-de-Stalingrad,
75019 Paris • +33 (0)1-80483340 •
See larotondestalingrad.com for opening hours

③ CAFÉZOÏDE
Very kids-friendly
92 bis Quai de la Loire, 75019 Paris •
+33 (0)1-42382637 Wed-Sun 10:00-18:00
www.cafezoide.asso.fr

ART GALLERY

⑩ THE WALL 51 (OFF THE MAP)
For its expertise in urban art
51 Rue de Presles, 93300 Aubervilliers
thewall51.com

LOCAL ATTRACTIONS

④ LA VILLETTE
211 Avenue Jean-Jaurès, 75019 Paris

⑤ PARIS PLAGE
La Villette lake becomes a beach

⑥ LES MARINS D'EAU DOUCE
7 Quai de la Seine, 75019 Paris
www.marindeaudouce.fr

Joachim Romain - Quai de l'Ourcq

THE DISTRICT FOR STREET ART FESTIVALS

Not only does Paris's 19th arrondissement have a high concentration of urban artworks – both ephemeral and longer lasting – this district can also boast two major events dedicated to street art that always attract crowds of art lovers, walkers, tourists and local residents.

OURCQ LIVING COLORS, A SITE OF EXCHANGES

Don't miss the Ourcq Living Colors festival in early June. It was the brainchild of dAcRuZ and is organised each year by the Cultures Pas Sages association. The aim is to build bridges between the residents of this multicultural district and other Parisians, and let them get to know and share street art in a festive atmosphere side by side with artists of international renown.

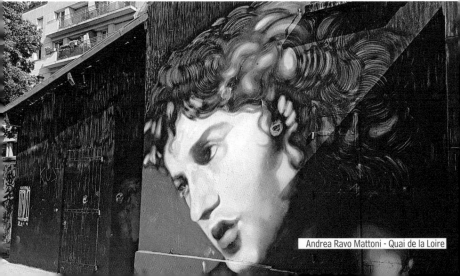

Andrea Ravo Mattoni - Quai de la Loire

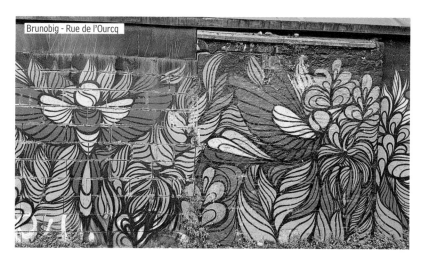

Brunobig - Rue de l'Ourcq

Visitors can experience great live performances and explore the colourful neighbourhood, whose large number of available walls, some intended for demolition, have attracted the crème de la crème of graffiti artists (one wall has a surface area of 200 m^2!). Various events in the margins of this festival help give it a lively and creative vibe, with photography exhibitions, special discovery routes dedicated to the festival, a village where you can works by schoolchildren supervised by artists, and so on.

The festival started by dAcRuZ has been going ten years now but is always looking for fresh ideas! The organisers are currently looking at how to increase the participation by the general public and how to showcase yet more artists from all around the world. As the situation in June 2020 prevented the festival from taking place under normal conditions, the organisers have chosen to organise small events throughout the summer - street art walks, live painting etc. Follow the Facebook page Ourcq Living Colors for more information. The 2021 edition is already in preparation!.

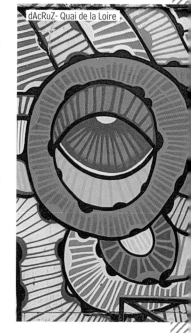

dAcRuZ- Quai de la Loire

Rue de l'Ourcq

Collective - Rue de l'Ourcq

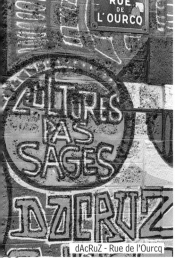
dAcRuZ - Rue de l'Ourcq

THE LATEST ADDITION: FESTIWALL!

In this district where urban art first took off, numerous associations promote street art as a genuine form of artistic expression that is enthusiastically embraced by the general public and can nurture social cohesion. They include the association DAM (De l'amour et des murs), which seeks to promote urban art by organising events: introductory workshops, live painting performances with free access, etc. Its aim is also to give the artists in this field – whether new or established – the opportunity to express themselves.

In a desire to take back control of a district that is changing fast and take advantage of the waterway 'corridor' crossing the district as far as Saint-Denis, the association joined forces with the urban art gallery The Wall 51 to organise a festival dedicated to street art and urban culture in May 2016, with financial support from the municipality of Paris's 19th arrondissement. People walking along the banks of Villette lake and Ourcq canal could enjoy a packed programme including performances by JBC, Tarek, Romain Froquet, Toctoc and many others. This is an exceptional opportunity to meet the artists and talk to them about the various techniques they use: collage, stencils or graffiti. The festival also includes creative workshops, dance performances and concerts, always centred on the theme of urban culture.

For the latest information, and details for the next edition of the festival, check out the gallery's website: www.thewall51.com

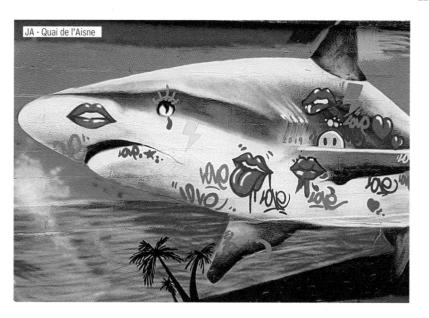

JA - Quai de l'Aisne

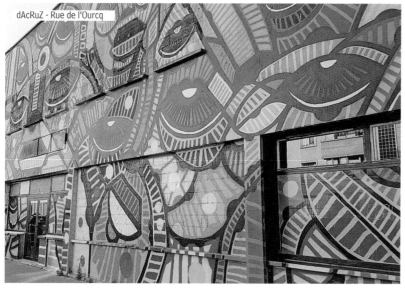

dAcRuZ - Rue de l'Ourcq

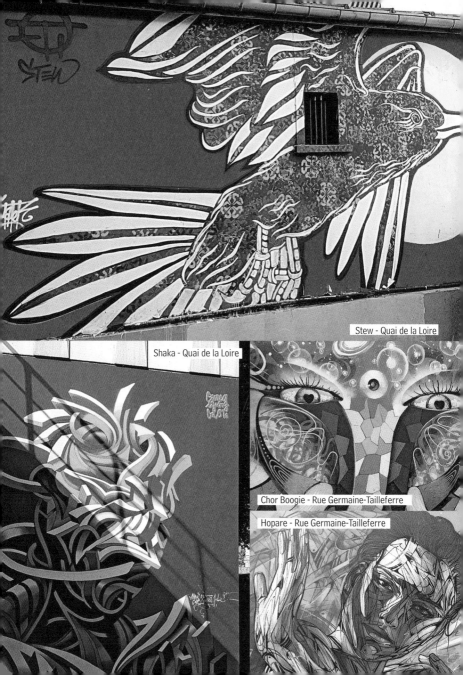

Stew - Quai de la Loire

Shaka - Quai de la Loire

Chor Boogie - Rue Germaine-Tailleferre

Hopare - Rue Germaine-Tailleferre

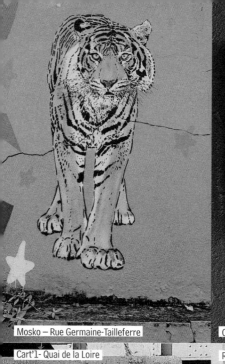

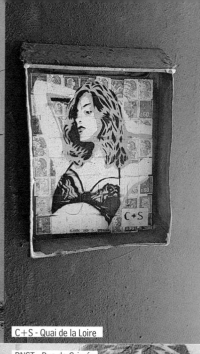

Mosko – Rue Germaine-Tailleferre

C+S - Quai de la Loire

Cart'1- Quai de la Loire

RNST - Rue de Crimée

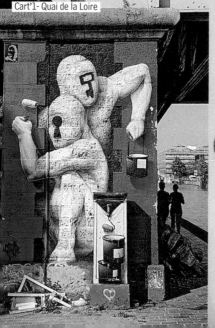

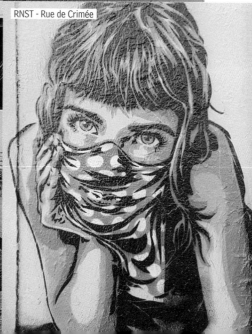

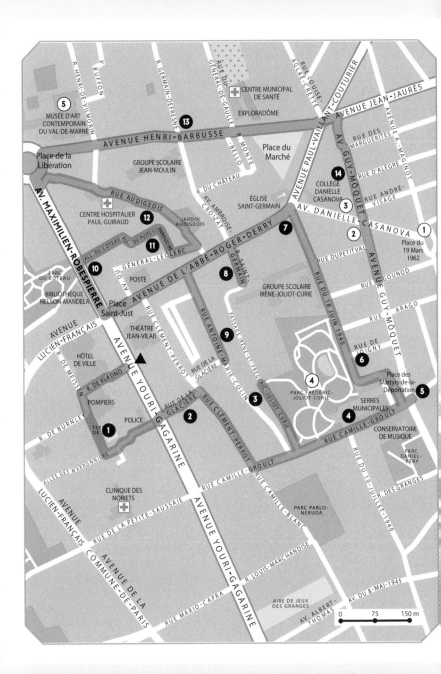

VITRY-SUR-SEINE,
showcasing urban art

Vitry has a connection with contemporary art going back to the 1960s. Its public spaces have been taken over by street art in the form of murals and graffiti signed by artists both local (Meushay, Bebar and Avaatar) and international (David Walker and Fin DAC). These artworks are fully integrated into the townscape. Local residents have embraced this heritage and appreciate the lively interest it generates.Allow one and a half hours for this walk to get a good view of everything.

FOLLOW THE GUIDE

You have two options coming from Paris to get to the starting point of this route (Vitry-sur-Seine town hall on Avenue Youri-Gagarine):
– Metro line 7 (Villejuif-Louis-Aragon station) and bus 180 (stop at Hôtel-de-Ville-de-Vitry);
– RER C (Vitry-sur-Seine station) and bus 180 (stop at Hôtel-de-Ville-de-Vitry).

When you get there, take Rue de Kladno and Rue de Meissen, which turns into Rue de Burnley. Take a look at the playground and the mural by Brok, one of the pioneers of street art in Vitry.

Brok - Rue de Burnley

Avataar - Rue de Meissen

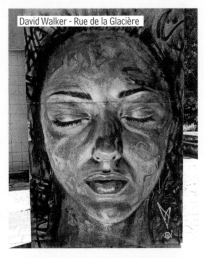

David Walker - Rue de la Glacière

Do a U-turn around the building and take the narrow steps to get back onto <u>Avenue Youri-Gagarine</u>. Cross the avenue and go down <u>Rue de la Glacière</u> ❷. Look around you and be impressed.

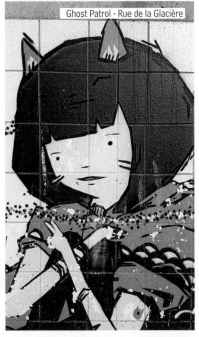

Ghost Patrol - Rue de la Glacière

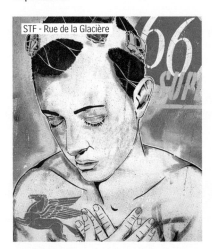

STF - Rue de la Glacière

Dan 23
Passage Irène-et-Frédéric-Joliot-Curie

Etnik - Rue de la Glacière

Take your time to absorb the works by Alice Pasquini, Fin DAC, STF and Vitry artists such as Avaatar and Bebar.

The next stop is <u>Passage Irène-et-Frédéric-Joliot-Curie</u> ❸. To get there, turn right onto <u>Rue Clément-Perrot</u> then continue briefly down <u>Rue Camille-Groult</u>).

VITRIOL IN VITRY

Bebar, a young artist with Spanish roots, grew up in Vitry-sur-Seine. His murals, inspired by hip hop and the cartoons of his youth (Looney Tunes, Tex Avery), show figures taking a caustic look at life in the street.

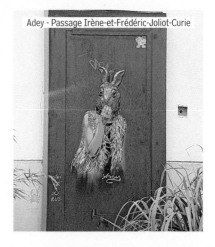

Adey - Passage Irène-et-Frédéric-Joliot-Curie

ARTIST IN THE SPOTLIGHT

*Born in 1980, Italian artist **Alice Pasquini** graduated from the fine arts academy in Rome and became an art critic at the age of 24, immediately afterwards signing her first work of street art. Soon her portraits were appearing in cities around the world: over one hundred, including Barcelona, Marseille, Copenhagen and New York. But she chose Vitry, a town open to creativity as the key to reinforcing the social fabric, as her base, where she paints profusely.*

Her engaged art focuses on images of female figures with a strong personality, far removed from stereotypes. So no woman-as-object or cartoon heroines.

The artist also draws inspiration from children. The range of techniques she uses (stencilling, drawing with Posca pens, painting) allows her to accentuate the effects of the material and add volume to her artworks.

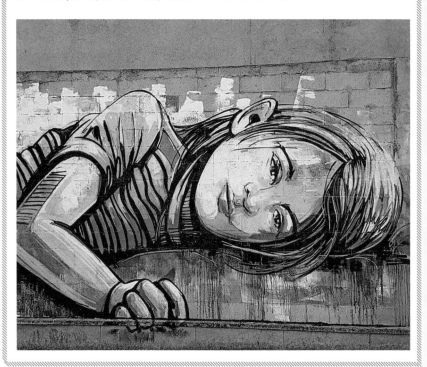

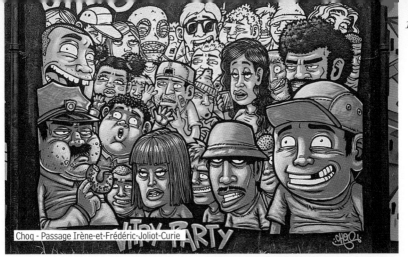

Choq - Passage Irène-et-Frédéric-Joliot-Curie

↘ Continue along <u>Rue Camille-Groult</u>
❹ past the edge of the park, where
Stoul's pretty redhead makes eyes
at you. Walk as far as <u>Avenue Guy-
Môquet</u> ❺ to discover a group work
signed by Artof Popof and dAcRuz.

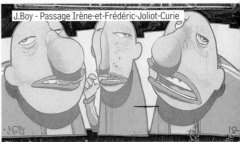

J.Boy - Passage Irène-et-Frédéric-Joliot-Curie

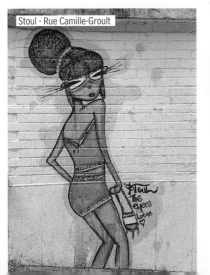

Stoul - Rue Camille-Groult

SHUTTER ART

The artist
with the
pseudonym #PrendsLeFacile practices
letter art, after discovering graffiti at
the age of 16 when travelling by train
between Paris and its working-class
suburbs. Since then, the artist has livened
up shop shutters and storefronts (among
other things) with brightly coloured or
monochrome lettering.

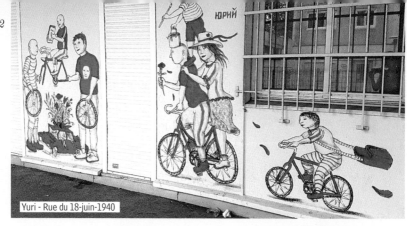

Yuri - Rue du 18-juin-1940

↘ Turn back and turn off onto <u>Place des Martyrs-de-la-Déportation</u> to get to <u>Rue du 18-juin-1940</u> ❻. Feast your eyes on this work by C215 adorning an electrical cabinet (one door of which has been salvaged by a fan). Further along on your left, down <u>Avenue de l'Abbé-Roger-Derry</u> ❼, you will come across Yuri, Stew and the vividly coloured world of Lyon's Birdy Kids.

MADE IN ASIA

Fin DAC is originally from Ireland and lives in London. His portraits stand ou for the attention h pays to the details as is evident in this superb young woman who typifies the artist's preference for Asian beauties.

Birdy Kids - Avenue de l'Abbé-Roger-Derry

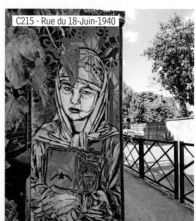

C215 - Rue du 18-Juin-1940

NOT TO BE MISSED!

*For **Christian Guémy, aka C215**, the street is the best place to produce a genuine interaction, not just between a variety of supports but also between the artist and their public. C215 moved to Vitry in 2009. He put up his stencils, basically portraits of his daughter, in the neighbourhood she was living in, leaving his mark on the walls to such an extent that it was not long before the municipality was contacting him. The municipality of Vitry was impressed by his artistic initiative and offered him the opportunity to create works on various supports. As C215 was also contacted by social housing organisations, he paired up owners and artists. In 2014, he opened his second studio in Ivry-sur-Seine. C215 uses his stencils to show his political engagement. In 2013 the artist produced a portrait of the Minister of Justice Christiane Taubira as a gesture of support when she was the butt of racist comments during the debate on the bill for marriage for all.*

In 2017, he did portraits of French sportspeople in both Vitry and Paris's 13th arrondissement in order to promote the capital's candidacy for the Olympic Games in 2024.

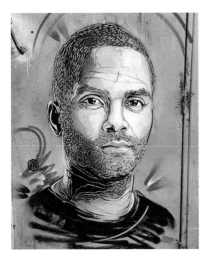

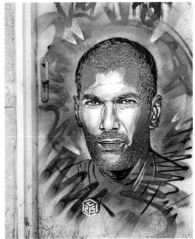

As you walk along the avenue, pop down <u>Rue Saint-Germain</u> **8** and <u>Rue Antoine-Marie-Colin</u> **9**. At the point where <u>Avenue de l'Abbé-Roger-Derry</u> meets <u>Avenue Maximilien-Robespierre</u>, turn right, then thread your way down <u>Allée du Coteau</u> **10** on your right to see creations by Alice (see p. 120) and L7 Matrix. Continue right along <u>Allée du Puits-Farouche</u> **11** where Nychos awaits you (behind the low wall).

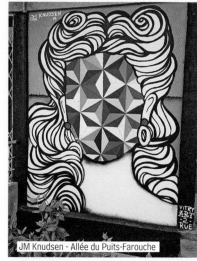
JM Knudsen - Allée du Puits-Farouche

Mad C - Rue Antoine-Marie-Colin

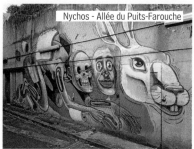
Nychos - Allée du Puits-Farouche

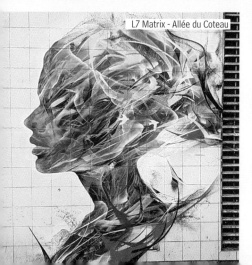
L7 Matrix - Allée du Coteau

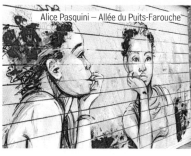
Alice Pasquini – Allée du Puits-Farouche

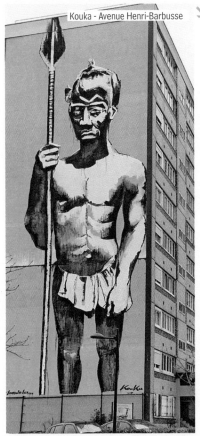
Kouka - Avenue Henri-Barbusse

↘ Continue left to reach <u>Rue Audigeois</u> ⑫ to conclude your walk in the company of Icy and Sot, Zabou, Thierry Noir, Mantra and Takt. At <u>Place de la Libération</u>, take <u>Avenue Henri-Barbusse</u> ⑬ with the colossal artworks by Kouka and HNRX. Finish by walking as far as <u>Place du Marché</u> and turning off down <u>Avenue Guy-Môquet</u> ⑭, where Alice Pasquini, C215 and Serty 31 have left their mark at the base of the buildings.

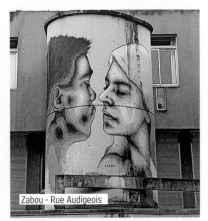
Zabou - Rue Audigeois

A FAMILY AFFAIR

Icy (born in 1985) and Sot (born in 1991) are brothers. Resident in the US, the two activist Iranian artists largely use stencils to criticise attacks on basic social and political freedoms.

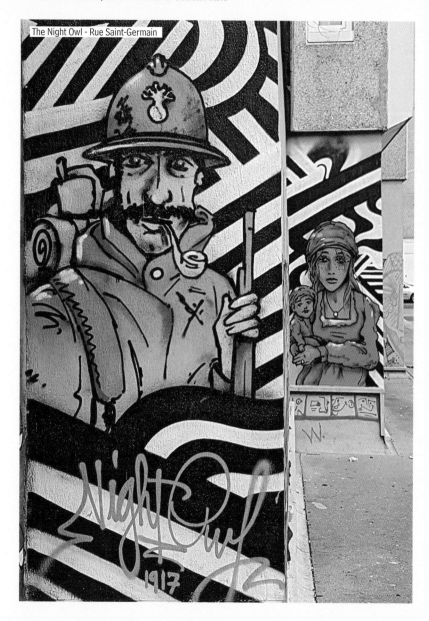

The Night Owl - Rue Saint-Germain

GOOD TO KNOW

In late September/early October, the **Murs Murs** festival shines the spotlight on urban culture for ten days. The aim is to spread art across public spaces, accompanied by an upbeat programme of concerts, dance, exhibitions, screenings, sports events, performances and urban walks, all thanks to socially engaged partners (associations). The 2017 edition saw the launch of a new route, the 'industrial trail', which mixed artistic performances with graffiti surprises.

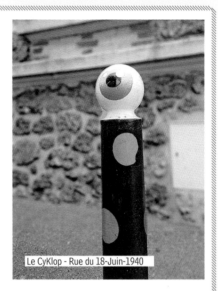

Le CyKlop - Rue du 18-Juin-1940

USEFUL ADDRESSES

BARS AND RESTAURANTS

① À LA FOLIE
MAC VAL art museum restaurant
Place de la Libération, 94400 Vitry-sur-Seine
+33 (0)1-45732668
Tue-Fri 12:00-18:00, Sat-Sun 12:00-19:00
restaurantalafolie.com

BOOKSHOP

② LE TOME 47
For fans of graphic novels
47 Avenue Guy-Môquet, 94400 Vitry-sur-Seine
+33 (0)9-72415539
Tue, Wed, Fri, Sat, 09:00-20:00, Thu 13:00-20:00,
Sun 10:00-13:00

ART GALLERY

③ GALERIE MUNICIPALE JEAN-COLLET
Contemporary art
59 Avenue Guy-Môquet, 94400 Vitry-sur-Seine
+33 (0)1-43911533
Tue-Sun 13:30-18:00, during exhibitions:
Wed 10:00-12:00/13:30-18:00
galerie.vitry94.fr

LOCAL ATTRACTIONS

④ FRÉDÉRIC JOLIOT-CURIE PARK
65 Rue Antoine Marie Colin, 94400 Vitry-sur-Seine

⑤ MAC VAL
For its exhibitions and its outdoor cafe — popular in the summer
Place de la Libération, 94400 Vitry-sur-Seine

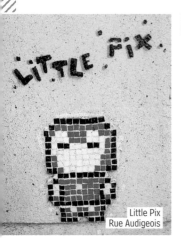

Little Pix
Rue Audigeois

Avataar - Rue Saint-Germain

Dona - Avenue de l'Abbé-Roger-Derry

THE VITRY'N URBAINE ASSOCIATION

Explore Vitry free from the clichés that dog the banlieues – that is the aim of Jean-Philippe Trigla, chairman of Vitry'n Urbaine, an association promoting graffiti and street art. He is an ardent fan of this generous, welcoming town that gets its energy from its social mix and its residents' ability to rub along.

The association was founded in 2013. During a Parisian visit in the footsteps of Invader, Jean-Philippe Trigla met Francis Verger, who blogs on vitrycitygraffiti.wordpress.com. The idea was to 'import' the concept to Vitry of these themed walks that let urban art enthusiasts discover a neighbourhood. Vitry'n Urbaine was able to make use of advice from the municipality's culture department. The first walks, which were free and publicised through social media, soon attracted up to fifty people at a time. For safety reasons, the association decided to charge a fee and limit the number registering to fifteen.

The route naturally pays particular attention to artists from Vitry of all generations, from veterans such as C215, Meushay and Dark Amour, to the generation that followed with Honde, Takos and Frenchmenvotre, and not forgetting the big names of today — Stew, Bebar with his fantastic use of colour, the talented stencil artist Avaatar, K.Bal, Dona and Little Pix, a group of mosaic artists (the local Invaders). The initiative's success enabled a partnership with the departmental committee for tourism in Val-de-Marne. This let the association become involved in major cultural events such as the Paris Face Cachée

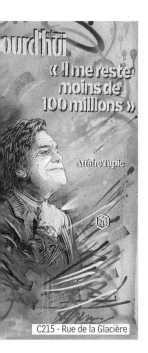

C215 - Rue de la Glacière

festival in 2015 and the European Heritage Days in 2016. While the association's core business is still the walks, Vitry'n Urbaine has taken over the tasking of pairing artists (who apply to the association) with social housing companies and other property owners with walls from C215. This new development was made possible thanks to a collaboration with the Campus Urbain association, architect of spatial innovation. Jean-Philippe Trigla wants to set up creative workshops introducing people to street art bombing and promoting contact between the artist and their public. But Vitry'n Urbaine also seeks to extend its scope beyond the town boundaries to the region as a whole by nurturing links with other associations, social housing corporations and property developers — all as part of a broader project entitled #pARTicipACTIF. Recently, the association has started activities in the neighbouring municipality of Choisy-le-Roi with group workshops focusing on street art.

For information on the walks organised by Vitry'n Urbaine, go to reservation.tourisme-valdemarne.com or the association's Facebook page (www.facebook.com/Vitrynurbaine/).

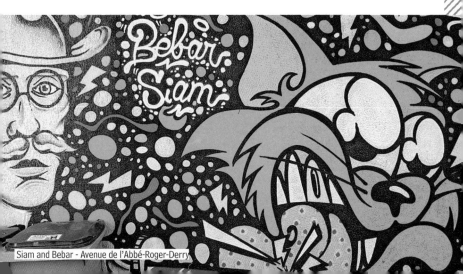

Siam and Bebar - Avenue de l'Abbé-Roger-Derry

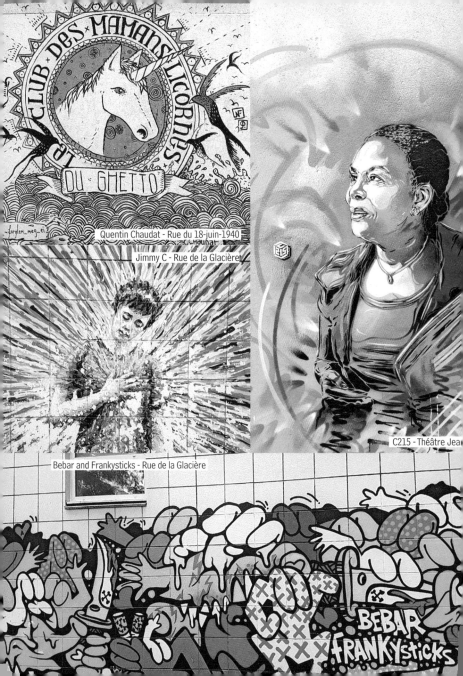

Quentin Chaudat - Rue du 18-juin-1940

Jimmy C - Rue de la Glacière

C215 - Théâtre Jea

Bebar and Frankysticks - Rue de la Glacière

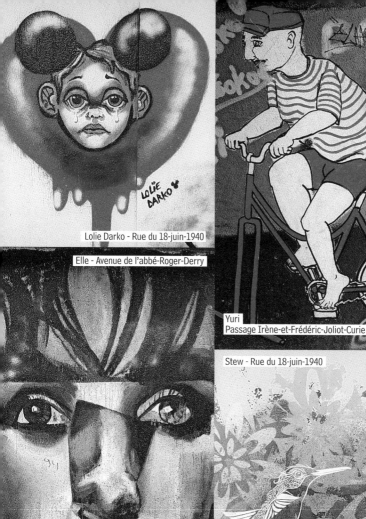

Lolie Darko - Rue du 18-juin-1940

Elle - Avenue de l'abbé-Roger-Derry

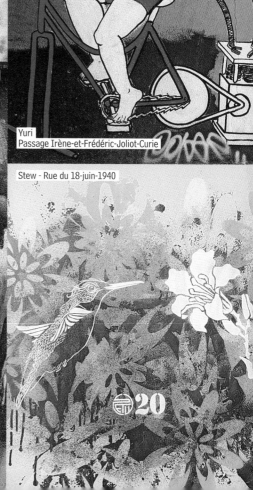

Yuri
Passage Irène-et-Frédéric-Joliot-Curie

Stew - Rue du 18-juin-1940

20

MONTREUIL,
a street art hub

The Montreuil route is quite long so wear some comfortable trainers to explore such must-see spots as Espace Albatros or local Croix de Chavaux Brewery, where works by FLM and Vinie grace the facades. On this route, you will have the opportunity to discover works by Montreuil artists including Espion, Seyb and Artof Popof, who have taken control of the public space. Allow about one and a half hours for your walk so that you can fully savour the vibe of this neighbourhood.

FOLLOW THE GUIDE ↙

The walk starts at the Robespierre metro station. Take <u>Rue Valette</u> , where you will discover a mural by Sébastien Dejancourt aka Seyb, created in 2012, and artworks by Barny. Take <u>Rue Voltaire</u> ❷ on your right and admire the Toobib'bike facade at no. 15, created by Espion. Turn onto <u>rue de Paris</u> ❸, where you can spot M.Chat and Oji on your left.

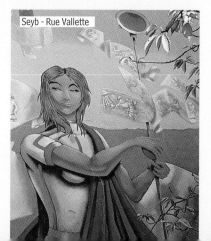
Seyb - Rue Vallette

M.Chat - Rue de Paris

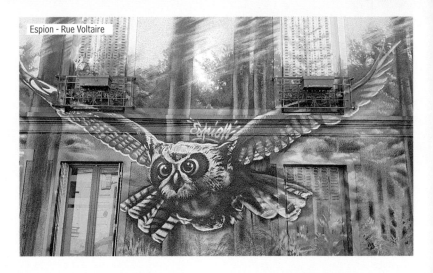
Espion - Rue Voltaire

⤵ Retrace your steps and head down Rue Barbès ❹ where Espion's huge, hard-to-miss owl watches over the street.

Get onto Rue Garibaldi ❺ to find a mural by Mister Pee and one by Soklak located close by, down Rue François-Arago ❻.

BARNY'S FACES

Self-taught Montreuil graffiti artist Barny started creating art in the streets in 2016. With roots in a diverse cultural and social environment, he takes a critical look at our society. You can find his collages in the streets of Montreuil and elsewhere.

Lalasaïdko and Bebar - Rue Garibaldi

Soklak - Rue François-Arago

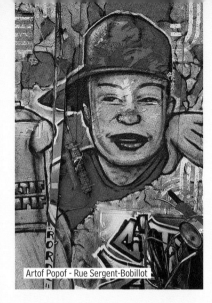

Artof Popof - Rue Sergent-Bobillot

Turn back and walk up to <u>Rue de Paris</u>. Turn right onto this road to get to <u>Place Jacques-Duclos</u> ❽, where you can see the mural The Women of Montreuil by Espion. Make your way down <u>Rue du Capitaine-Dreyfus</u> ❾ where you will find Le CyKlop's bollards.

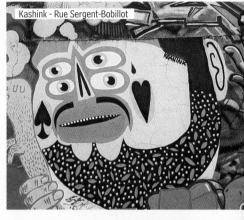

Kashink - Rue Sergent-Bobillot

↘ Continue the walk along <u>Rue Douy-Délcupe</u>, then turn right into <u>Rue Sergent-Bobillot</u> ❼ and prepare to be dazzled by the wall of the Albatros cultural centre, with works by Artof Popof, Kashink, Mesnage and many others.

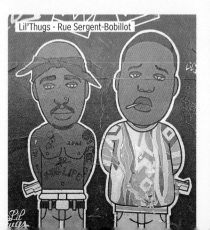

Lil'Thugs - Rue Sergent-Bobillot

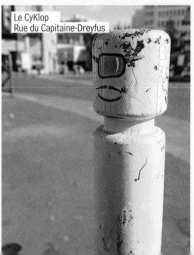

Le CyKlop
Rue du Capitaine-Dreyfus

FOLLOW THE BENDS

Using paintbrush and bombing, Artof Popof introduces us to different worlds, delighting us with his meandering lines that become entangled on the walls. In 2005, he started the Traits d'Union festival in cultural centre Espace Albatros.

↘ Walk to <u>Rue Victor-Hugo</u> ❿ by following Artof Popof's curves on the path and an Invader marking the intersection.

Various works by Espion can be found in this street. Continue onto <u>Boulevard Paul-Vaillant-Couturier</u> until you get to <u>Rue des Epernons</u> ⓫ to view works by Tarek, Akiza and other artists on the walls of urban art studio Atelier des Epernons.

MOSKO'S ARK

This artist, whose pseudonym comes from the Parisian district where he started operating (Moskova in the 18th arrondissement), has been a presence in the capital since the late 1980s and is a particular fan of Montreuil.

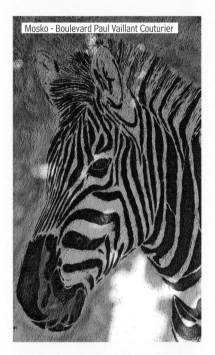

Mosko - Boulevard Paul Vaillant Couturier

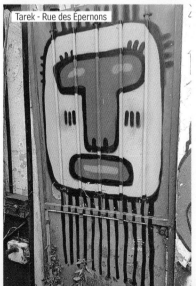

Tarek - Rue des Epernons

ARTIST IN THE SPOTLIGHT

Illustrator, painter, graffiti artist, bill poster and urban artist – **Mister Pee** likes wearing many hats. Like his characters, the Parisian artists describes himself as a free spirit. Growing up on a diet of comics and inspired by his photographer father, he discovered graffiti in the 1990s.

At the age of 14, he was operating under the name Onyx in the streets of the 13th arrondissement near the Frigos artists' hangout. After completing his education, this fan of hip-hop and rap culture discovered publishing and graphic art. In the 2000s, his blue bird nicknamed Mister Pee became a recurring feature in the monthly science magazine for kids Sciences et Vie Découvertes.

While that collaboration stopped, the nickname stuck and his universe once again spread to the streets, now with large-nosed human figures added. Comical and offbeat, his art invites passers-by to join in the amusement. Inspired equally by the Polish graphic artist Roman Cie lewicz and by Keith Haring, Mister Pee regularly lets his creatures loose in the Parisian streets, with solo exhibitions and collective interventions in other cities including Marseille, La Rochelle and even Lisbon.

To end this colourful walk, head towards Croix de Chavaux Brewery at <u>8, Rue Désirée-Charton</u>, via <u>Rue Victor-Beausse</u> **12** to admire the portrait of Basquiat by Oji. When you get to the brewery **13**, based in former artists' studios including that of Vinie, you can enjoy a glass of the local beer. The brewery's facade is covered with artworks and, as the icing on the cake, you can take the <u>track</u> **14** round the back of the place to get to a hidden work by Vinie.

FLM - Rue Desirée-Charton

NOT TO BE MISSED!

Espion, a French graffiti artist whose tag means 'spy' in a nod to James Bond, became involved in hip hop culture in the 1980s before adopting graffiti as his mode of expression. He has been adding colour to the walls of the town of Montreuil ever since 2001, paying homage to its residents or taking inspiration from totem animals. His eclectic work focuses on the theme of the gaze, whether human or animal, inviting the viewer on a journey and offering a moment of contemplation. In 2015, he won the Silver Street

Art prize during the Montreuil Street Art festival for his owl mural that can still be seen in Rue Barbès. In 2018, Espion set up the Aérosol association, which offers activities centred on urban art.

GOOD TO KNOW

Built in 1904 by Charles Pathé, **Espace Albatros** was originally a rival film studio to the Star Film company owned by the director Georges Méliès. The cultural centre is run by Lucien Chemla and his wife Lily. It focuses on art and performance (music, theatre, cinema, street art etc.). It aims to be a meeting place for artists, local residents and enthusiasts.

52 rue du Sergent-Bobillot, 93000 Montreuil
www.espacealbatros.fr

USEFUL ADDRESSES

BARS AND RESTAURANTS

(1) REST'ICI
ICI Montreuil's restaurant, with great decor and exhibitions
135 Boulevard Chanzy, 93100 Montreuil •
+33 (0)6-82282989
Mon-Fri 12:00-15:00

(2) LE BAR DU MARCHÉ
Cocktails, lively pavement cafe in summer
9 Place du Marché, 93100 Montreuil •
+33 (0)1-42980512
Every day, 07:30-24:00

(3) CROIX DE CHAVAUX BREWERY
Distinctive place run by enthusiasts
8 Rue Désiré-Charton, 93100 Montreuil •
+33 (0)9-80642827
Fri-Sat 16:00-21:00

BOOKSHOP

(4) ZEUGMA
For their cultural events
5 bis Avenue Walwein, 93100 Montreuil •
+33 (0)1-76583641
Tue-Sat 10:00-20:00

ART GALLERY

(5) ABCD LA GALERIE
For fans of outsider art
12 Rue Voltaire, 93100 Montreuil •
+33 (0)6-22267056
abcd-artbrut.net

LOCAL ATTRACTIONS

(6) GEORGES MÉLIÈS CINEMA
12 Place Jean-Jaurès, 93100 Montreuil

(7) TIGNOU CONTEMPORARY ART CENTRE
116 Rue de Paris, 93100 Montreuil

(8) ICI MONTREUIL
135 Boulevard Chanzy, 93100 Montreuil

(9) ATELIER DES EPERNONS
14 Rue des Epernons, 93100 Montreuil

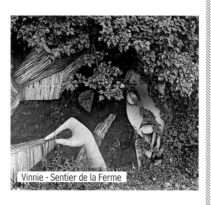
Vinnie - Sentier de la Ferme

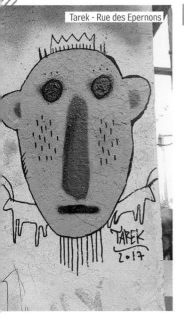

Tarek - Rue des Epernons

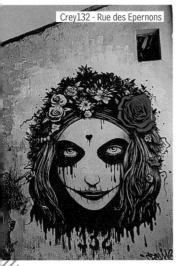

Crey132 - Rue des Epernons

MONTREUIL, SITE OF URBAN CREATIONS

Along with its high concentration of street artworks, Montreuil also benefits from collectives and associations dedicated to urban art. Which in turn attract crowds of tourists, local residents and other artists.

ICI MONTREUIL, A CULTURE-MAKER

Located five minutes from Croix-de-Chavaux metro station, this factory building with 1,800m² of floor space houses entrepreneurs, designers, artists and craftspeople in shared studios. Its aim is to make its co-working space a springboard (in both material and artistic terms) for young creatives who have moved to Montreuil. Founded in October 2012, this Fab Lab now has over 160 monthly subscribers.

Although Ici Montreuil focuses on various crafts, it also pays attention to street art. It regularly organises themed exhibitions, which have local and other artists in the spotlight, including Olivia de Bona, JBC, Alice and Gilbert Mazout.

The place is open to the public during specific events but you can always visit by making a reservation: go to the website http://makeici.org/icimontreuil (where you can also find the current cultural programme).

A STUDIO BUZZING WITH URBAN ART

Founded in January 2017, Epernons Studio serves as a museum for contemporary and urban art but is above all a place for the resident artists to work (Barny, Paddy, Vincent Bruno, Bricedu, Mihael Milunovic).

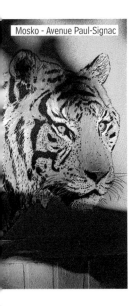

Mosko - Avenue Paul-Signac

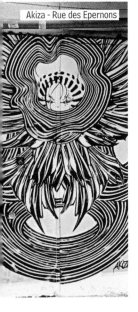

Akiza - Rue des Epernons

They in turn invite other artists to get creative on the building's interior and exterior walls, in return for free participation. Workshops for the young and the young at heart are also organised by Bricedu in this former factory with floor space of 200m^2.

While the long-term future of the place is uncertain, it continues to welcome the general public free of charge on certain weekends to meet the resident artists. Visitors are however invited to make a donation. Some of that money will be given to Utopia 56, an organisation working for migrants. The socially engaged Epernons Studio also works with the Collectif des 3 Couronnes organisation to assist people in vulnerable circumstances.

LA GRAFFITERIE, STREET ART COLLECTIVE

In this Montreuil collective, Joachim Prompsy (alias JOC), Zoé Caïe (alias Caïllou), Morf, Béatrice Boubé, Yoann Truquin and Élie Mora are rethinking the appropriation of urban space in Montreuil.

Defining itself as 'a virtual site for encounters', the organisation regularly covers walls in the locality with temporary murals. It also produces outdoor murals on request for property owners and private individuals. Its aim is to connect institutions, associations and local residents with art that is part of everyday lives. To achieve this, it regularly runs participatory workshops to raise awareness among locals about street art.

The La Graffiterie artists are actively involved in Montreuil's festivals and cultural events, and they love to share their creations on the collective's official website. For more information, see www.graffiterie.fr.

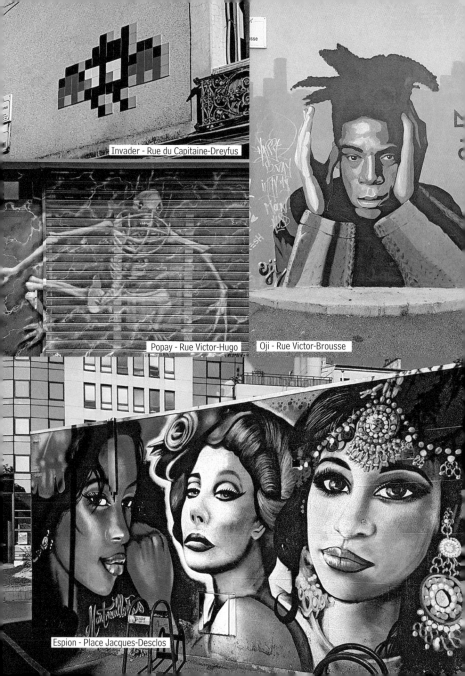

Invader - Rue du Capitaine-Dreyfus

Popay - Rue Victor-Hugo

Oji - Rue Victor-Brousse

Espion - Place Jacques-Desclos

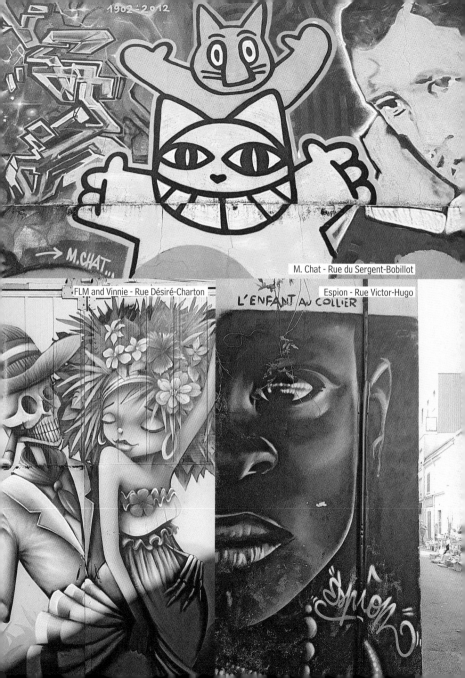

1982 - 2012

→ M.CHAT...

M. Chat - Rue du Sergent-Bobillot

FLM and Vinnie - Rue Désiré-Charton

Espion - Rue Victor-Hugo

L'ENFANT AU COLLIER

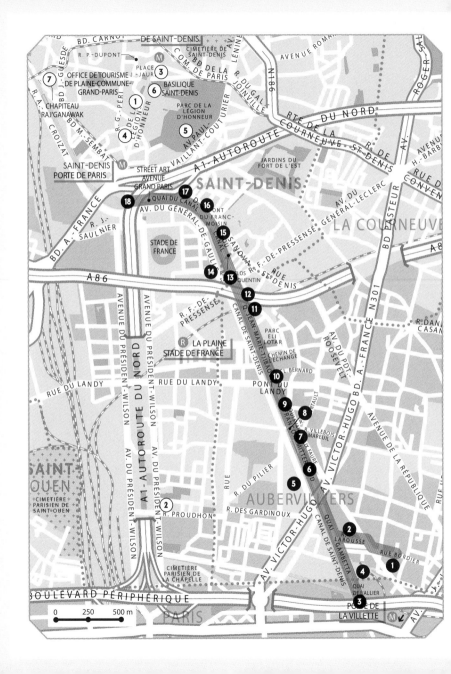

AUBERVILLIERS AND SAINT-DENIS,

street art going with the flow

Saint-Denis has been a must-see route for street art fans for some years now. From the Aucwin project, executed in 2015, to the Street Art Avenue Grand Paris created in 2016, there is plenty for you and your family or friends to enjoy along the Saint-Denis canal. If you choose to do the route on foot, allow one and a half hours (it's quite a long walk between some of the artworks). The ideal solution is to go by bike.

FOLLOW THE GUIDE

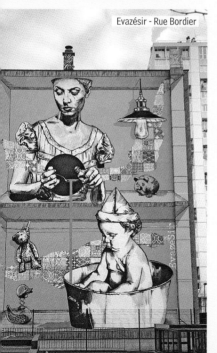
Evazésir - Rue Bordier

After exiting Porte-de-la-Villette metro station, head off to <u>39, Rue Bordier</u> ❶ to start the route with the large mural by Evazésir, created in June 2019 as part of the Regard Neuf festival. At the end of the street, turn right onto <u>Boulevard Félix Faure</u> to get to <u>Rue Pierre-Larousse</u> ❷ (second on the left). You will find various murals on both sides.

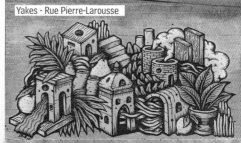
Yakes - Rue Pierre-Larousse

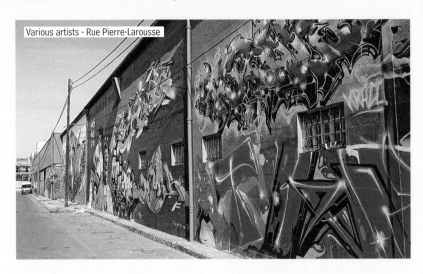
Various artists - Rue Pierre-Larousse

➘ At the end of the street, turn left and take <u>Quai Gambetta</u>, which becomes <u>Quai de l'Allier</u>, alongside the canal until you get to the ring-road bridge. The pillars ❸ have been decorated with portraits by Guaté Mao.
Turn back and note the many tags covering the wall alongside the canal. They can be found along the entire route. As you return along <u>Quai Gambetta</u>, look out for the gable on the house before the canal lock, painted by Seth ❹.

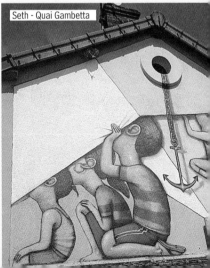
Seth - Quai Gambetta

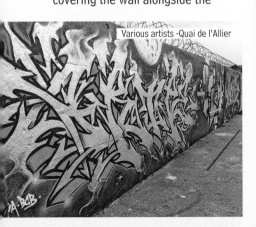
Various artists -Quai de l'Allier

EVAZÉSIR

Who are you?

We are Eva and Sir, an artistic duo who sign their works with the pseudonym EvazéSir. We belong to the multi-disciplinary collective No Rules Corp.

When did you start working in the streets and why?

We've been swapping and sharing techniques since 2009. Eva is more a product of art college and working in studios whereas Cyril is from the streets and graffiti on abandoned land. Eva inspired Cyril to paint on canvas while Cyril got Eva out of her studio. Our collaborative work soon became larger and larger, with very conspicuous murals.

What triggered you to start doing street art?

The desire to produce ever larger artworks. The format you can have is restricted in a studio whereas there are fewer limits in the street and the visual impact is greater as a result.

What is your main source of inspiration?

Time, life, societies ancient and modern. We liking bridging the gap between generations, creating temporary and nostalgic links in our murals. Our creations derive their power from the combination of found objects (wood, old objects etc.) and the site where they are installed. Our studio work is all about using figures, personas and motifs that bring the material to life, letting it breathe and summon up an imaginary world.

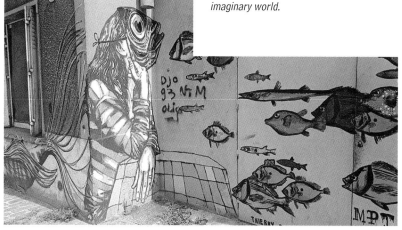

⟶ Continue your walk. After the bridge you get onto <u>Quai François-Mitterand</u>, from where you can see the cement works silos ❺ on the other side of the canal that have been customised by Guaté Mao. A little further along after the lock (where the sports facilities are), a long mural by Kazy Usclef adorns the outer wall around <u>Square Aimé-Césaire</u> ❻.

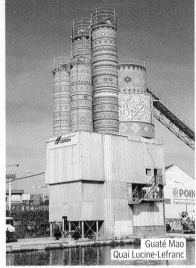

Guaté Mao
Quai Lucine-Lefranc

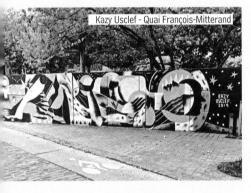

Kazy Usclef - Quai François-Mitterand

At the point where <u>Quai François-Mitterand</u> and <u>Rue Heurtault</u> meet, discover the work by Polar ❼ with its brightly coloured geometric shapes. Somewhat further along is Jungle's smiling red dog ❽.

AN AWESOME DOG

If you come across a red dog bursting with good spirits, you have found a work by Jungle. He has been drawing since... forever. He sees dogs as the spectre of humans, in a red that can mean danger but also passion!

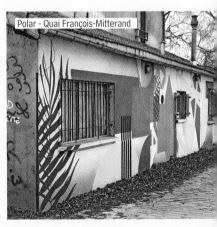

Polar - Quai François-Mitterand

Continue your stroll as far as where <u>Boulevard Félix-Faure</u> and <u>Quai François-Mitterand</u> meet, and stop to admire the Egyptian mural ❾ by Funky Déco Group.

Pass under the <u>Rue du Landy bridge</u>, and you will be on <u>Quai du Canal-Saint-Denis</u> with the mural Ensemble by Joachim Romain ❿ on the wall on the right.

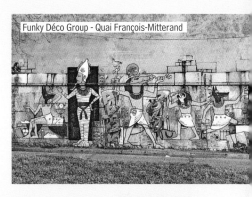
Funky Déco Group - Quai François-Mitterand

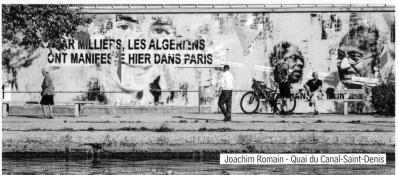
Joachim Romain - Quai du Canal-Saint-Denis

NOT TO BE MISSED!

Culture and creativity take pride of place in this former office block with floor space of 7,000 m². Over ten years, 6b (6-10 Quai de Saint-Denis) has become a leading cultural centre in Saint-Denis. You will find a highly diverse programme with concerts, performances and exhibitions. The association also offers professionals in the cultural sector 170 private studios at very competitive prices.

6b is always actively involved in urban culture, for example organising a street art route (Aucwin) during the FAR event in 2015 with about thirty artists along the canal. This project was initiated by two residents: Jungle and Joachim Romain.

Continue along the canal and after the footbridge you will be on <u>Quai Jean-Marie-Tjibaou</u>. Walk past the lock and continue under two bridges. The second has been painted in geometric shapes by Roid 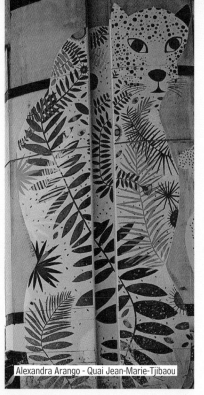. Continue to get to the <u>viaduct over the Canal</u>. Artistic duo Fimo & Dizzy and Alexandra Arango ⑪ have painted the underside of the bridge on both sides of the canal, to our delight.

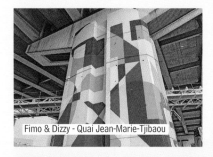

Fimo & Dizzy - Quai Jean-Marie-Tjibaou

Alexandra Arango - Quai Jean-Marie-Tjibaou

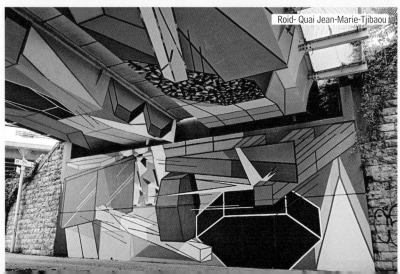

Roid- Quai Jean-Marie-Tjibaou

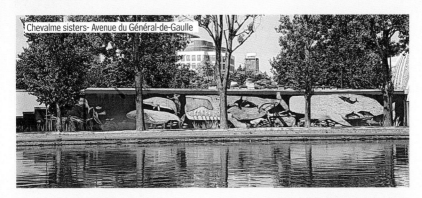
Chevalme sisters- Avenue du Général-de-Gaulle

A little further along, under <u>Francis-Pressensé bridge</u>, there is a large mural by the artist Zest **12**. Just after this, admire the mural of animals by Marko 93 and the underwater world of the Chevalme Sisters **13**.

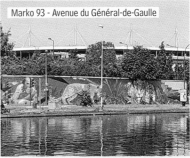
Marko 93 - Avenue du Général-de-Gaulle

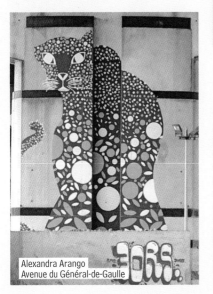
Alexandra Arango
Avenue du Général-de-Gaulle

TWO OF A KIND

Twin sisters Delphine and Élodie (aka the Chevalme sisters) took different routes – one studying graphic art and the other architecture – before developing joint projects like this one in Saint-Denis. These all-rounders started with felt-tip pens but work mainly with rollers and brushes these days.

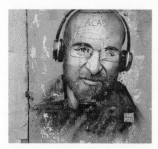

TRAVELLING WITH GUATÉ MAO

You can easily recognise Guaté Mao's stencils from the black background that serves to highlight his portraits of people he has come across on his various travels. His preferred technique? The stencil, often using three layers to accentuate the gradients. The ones created along the canal are a first for him because of their size.

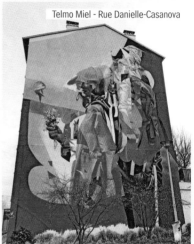

Telmo Miel - Rue Danielle-Casanova

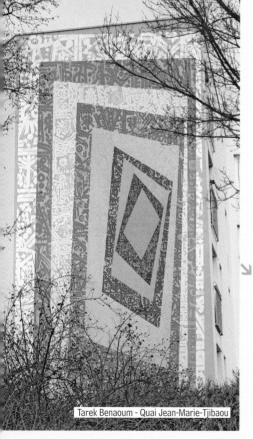

Tarek Benaoum - Quai Jean-Marie-Tjibaou

Continue for 300 metres and then on your right, just before the Franc-Moisin footbridge, you will find the calligraphic mural painted by Tarek Benaoum **14** for the fourth edition of Street Art Avenue. Continue walking along the canal until you get to the steps at 84, Rue Danielle-Casanova, where you will find a mural by Dutch duo Telmo Miel **15**.

ARTIST IN THE SPOTLIGHT

*Born in Le Havre in 1973, **Joachim Romain** has been immersed in art, printing and advertising since a very young age. These are the fields he is interested in and that inspire his work. As a result, he is alert to the possibilities of lettering and typography.*

Advertising posters have become the preferred material to work with for this multi-talented artist (adept in photography and the plastic arts). He recycles them, tears them or burns them in order to put portraits of celebrities or anonymous individuals in the spotlight with the aid of an aerosol can. The worn state of the posters is an inherent part of his creations, calling into question their lifecycle at the same time.

These days, Joachim Romain's work is regularly on display in exhibitions in France and abroad. He also takes

part in festivals, such as Festiwall in Pantin.

If you take the suggested route, you will be able to discover his work in the form of a mural remembering the police repression of demonstrations for a free Algeria on 17 October 1961.

La Dewolf- Quai du Canal-Saint-Denis

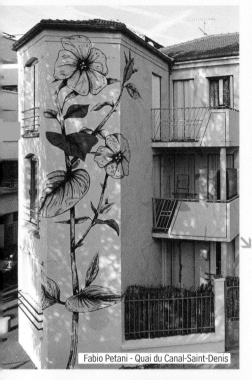

Fabio Petani - Quai du Canal-Saint-Denis

Further along, opposite the Stade de France sports stadium, is a house repainted by Fabio Petani **16**. Finish your walk on the banks of the lock with pillars painted by Rébus, a wall by Joachim Romain **17**, steps decorated by Moyoshi and, on the other side of the lock, La Dewolf's foxes.

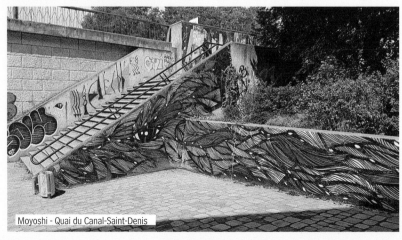

Moyoshi - Quai du Canal-Saint-Denis

GOOD TO KNOW

Saint-Denis has its own **M.U.R.** (mur = wall), officially opened on 14 July 2018! The association in charge of it aims to increase appreciation of the old-style graffiti and the pioneering artists while also promoting talented young locals. Swen, Foofa, Psyckoze and others have already had the pleasure of creating art that local residents can enjoy.

A new work appears once every two months opposite the market at 3, Rue Pierre-Dupont 92300 Saint-Denis.

Kraken

USEFUL ADDRESSES

BARS AND RESTAURANTS

① O'GRAND BRETON
For its flavours and freshness
18 Rue de la Légion-d'Honneur, 93200 Saint-Denis
+33 (0)1-48201158 • Mon-Fri 08:30-15:00,
Thu-Fri 18:00-22:00
ograndbreton.wordpress.com/cuisine

② LE CAFÉ DES ARTS
For their generosity
3 Rue Proudhon, 93200 La Plaine-Saint-Denis
+33 (0)9-70385656 • Mon-Fri 08:00-23:45
http://cafedesarts-stdenis.fr.zenchef.com/

ⓞ LE CIBO (OFF THE MAP)
A unique vegetarian menu
6-10 Quai de Seine-Saint-Denis, 93200 Saint-Denis
+33 (0)1-42432334 • Mon-Fri 12:30-14:30,
Fri 19:00-01:00
www.le6b.fr

BOOKSHOP

③ FOLIES D'ENCRE SAINT-DENIS
Does justice to its name of 'madness in ink'
14 Place du Caquet, 93200 Saint-Denis
+33 (0)1-48092512 • Tue-Sat 10:00-19:00
foliesdencre-stdenis.blogspot.com

ART GALLERY

④ 60 ADADA
Run by an association of local artists
60 Rue Gabriel-Peri, 93200 Saint-Denis
+33 (0)7-58052799 • Tue+Wed+Sun 14:00-19:00, Thu-Sat 15:00-20:00
www.60adada.org

LOCAL ATTRACTIONS

⑤ LÉGION D'HONNEUR PARK
⑥ BASILICA OF SAINT-DENIS
1 Rue de la Légion d'Honneur, 93200 Saint-Denis

⑦ CHAPITEAU RAJ'GANAWAK (CIRCUS)
3 Rue Ferdinand Gambon, 93200 Saint-Denis

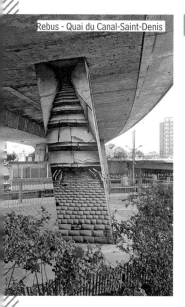

Rebus - Quai du Canal-Saint-Denis

STREET ART AVENUE

The banks of the Saint-Denis canal have been bursting with colour ever since July 2016 when the Euro 2016 football championship was held in France.

If you go from the Porte de la Villette metro station to the Stade de France stadium via Aubervilliers, you will be able to admire works by various artists on a range of surfaces, such as bridge pillars, factory silos and quaysides. These works, most of which are permanent, have been signed by such artists as Marko 93, Seth, Joachim Romain, Jungle, Evazésir, Alexandra Arango, the Chevalme Sisters and Guaté Mao.

The organisation behind this effort to promote the little-known canal is the Plaine-Commune-Grand-Paris tourism office. With its Street Art Avenue Grand-Paris project, it is using street art to revitalise this canal and promote its industrial past. This artistic route stretches more than four kilometres along the canal and into Aubervilliers, and allows you to explore various techniques including plastered photographs, stencils, aerosol spraying and acrylic paintings.

New works have been added to the route each summer since it opened in 2016. The most recent murals were created in 2019 during the Été du Canal festival in which about twenty graffiti artists painted a 150-metre long wall in Rue Pierre-Larousse, Aubervilliers in the Auber Graffiti Show. The Plaine-Commune-Grand-Paris tourism office also offers cruises and lectures (summer only) that let visitors discover how this art has left its mark on the area. You can also opt to do the route on foot or on a scooter. For more information, see the tourism office's website, https://www.tourisme-plainecommune-paris.com

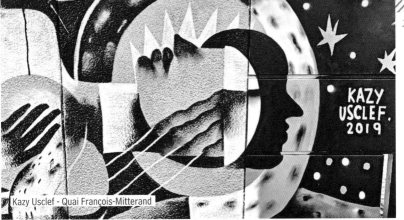

Kazy Usclef - Quai François-Mitterand

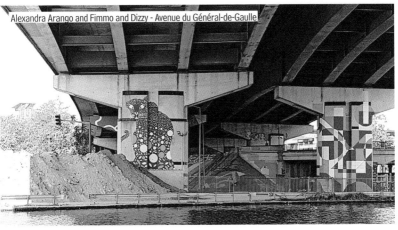

Alexandra Arango and Fimmo and Dizzy - Avenue du Général-de-Gaulle

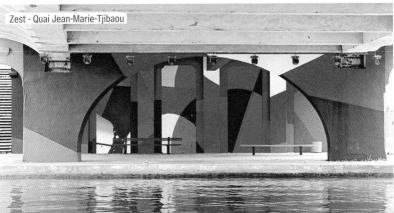

Zest - Quai Jean-Marie-Tjibaou

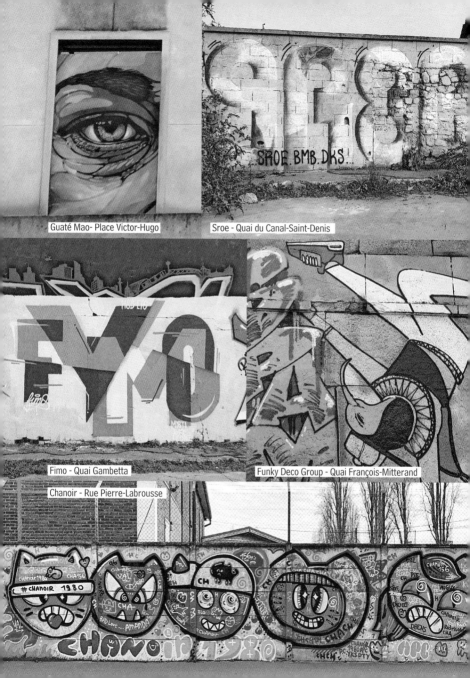

Guaté Mao- Place Victor-Hugo

Sroe - Quai du Canal-Saint-Denis

SROE. BMB. DKS...

Fimo - Quai Gambetta

Funky Deco Group - Quai François-Mitterand

Chanoir - Rue Pierre-Labrousse

ner OBK and Crey 132 - Rue Pierre-Larousse

zésir - Quai Jean-Marie-Tjibaou

Joachim Romain - Quai du Canal-Saint-Denis

Various artists -Quai de l'Allier

FURTHER AFIELD

As well as the ten routes in this guide, there are other great places for street art fans to visit. Here are some suggestions.

IN PARIS

↘ If your poor feet are still up to it after completing the route 'From the République to 104' (see p. 41), you can carry on as far as **Rue Ordener à Paris** in the 18ᵗʰ arrondissement where you will find a 300-metre long wall covered in graffiti, for your eyes only!

↘ Explore the depths of **Palais de Tokyo** (16ᵗʰ arrondissement): the Lasco Project, started in 2012, lets you explore the building's subterranean passages with signed works by major artists. A must!

↘ The world's first floating urban art centre, **Fluctuart** (Pont des Invalides, Port du Gros-Caillou, 7ᵗʰ arrondissement) has rapidly become a key player in the Parisian street art scene. With 1000 m² on three floors, the centre houses a permanent collection, various

Alëxone - Hôpital Necker

temporary exhibitions, a specialist bookshop, a bar and restaurant, and a rooftop area. Admission is free. See the website fluctuart.fr for the programme.

↘ Even if you aren't a huge fan of his songs, a visit to **Serge Gainsbourg's house** (Rue de Verneuil, 7th arrondissement) is worth it for all street art lovers. The outer wall in front of this historic house is covered with graphic art homages to the singer, who died in 1991.

↘ If you happen to pass through the 6th arrondissement, take a look at **Necker hospital**, where Keith Haring and Vhils have produced some impressive murals. You will also find a mural by Alëxone, completed in September 2019.

↘ Looking for street art in unusual places? Then visit the **Catacombs**, 1 avenue du Colonel-Henri-Rol-Tanguy in the 14th arrondissement, where you will discover works by prolific artist Psyckoze, on view on the official tours.

↘ As an extension of the '13th arrondissement' route, explore the **Bercy skate park**, Rue du Sahel in the 12th arrondissement, whose walls were decorated by street artists in 2017 as part of the 'Mur du 12e' programme. Théo Lopez, Emma Mery, Stew and Monsieur Qui were among the first to answer the call. If you follow the René-Dumont green trail, you will also come across works by street artists.

↘ Since spring 2019, the 78 cabins surrounding Molitor's indoor swimming pool (Rue Nungesser-et-Coli, 16th arrondissement) have been painted by 78 artists to produce a large gallery of urban art. Visit free of charge or reserve a guided tour: www.mltr.fr/fr/visites-des-cabines/.

Jace - Indoor pool

IN THE BANLIEUES

↘ In the heart of the neighbourhood **Mont-Mesly à Créteil**, the 'Mur des Émouleuses' programme invites artists to take over old buildings. Managed in part by local residents and the municipal children's council, it also organises participatory workshops for the local youth. The result? Loads of stencils and portraits of the people of Créteil, signed by Skio and Ernesto Novo.

↘ Not far from the 20th arrondissement, **the town of Bagnolet** is worth a proper visit. You will find works signed by Le CyKlop, Bagnolet graffiti artist Kongo, Psyckoze, Maniak Mkone, Gilbert Mazout and C215 in the vicinity of Gallieni metro station and in Rue du Général-Leclerc and Rue Charles-Graindorge. See www.tourisme93. com for a map.

↘ The official website of **the town of Malakoff** has an interactive map dedicated to various street art creations identified in its streets, signed for example by Le CyKlop (Rue Eugène-Varlin) or Le Mouvement (Rue Raymond-Fassin, Rue Béranger).

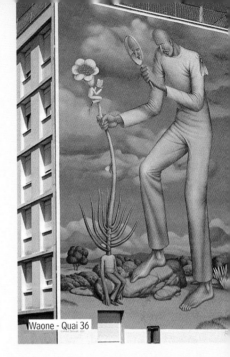

Waone - Quai 36

↘ As of April 2019, Quai 36 has chosen nine international street artists to create murals on nine walls measuring 150m^2 as part of the redevelopment of the **Bernard de Jussieu neighbourhood in Versailles**. This project will take one year and is divided into three phases. The first involved Waone, Eron and Telmo Miel. It was due to end in spring 2020 with works by Aryz, Mona Caron, Pastel and Sainer.

⬐ Between summer 2019 and autumn 2020 in **the Bac neighbourhood of Clichy**, Citallios worked with Quai 36 to come up with the first urban cable-car system for earthmoving. This system enabled earth and rubble to be removed from building sites using suspended skips. The solution is better for the environment and for the quality of life of local residents. The artist Blo appropriated two of these skips to give locals a unique hovering spectacle.

⬐ Visit the **Saint-Ouen flea market** (Garibaldi metro station) and stroll through the surrounding streets to see artworks by C215, Fred le Chevalier, Jérôme Mesnager and many others. Numerous artists have also painted the steel shutters to add colour to the town. The Plaine Commune Grand Paris tourist office offers a guided tour.

C215

STREET ART WALKS

In addition to the routes in this guide, there are other longer walks that let you imbibe street art in the Île-de-France region.

⬐ A walk suggested by Val-de-Marne Tourism **starts at the Arts et Métiers technology institute** (151 Boulevard de l'Hôpital, 75013). It lets you discover the street art in the 13th arrondissement, then cross the Paris ring road to admire the art in Vitry-sur-Seine.

⬐ An initiative of the associations Enlarge Your Paris, Vitry'n Urbaine, Des Ricochets sur les Pavés and Campus Urbain, **a major 12-kilometre urban walk** links up Paris, Gentilly, Arcueil, Ivry and Vitry-sur-Seine. The idea is that this signposted route will unite the various administrative communities that make up Paris's southern suburbs, the Grand Paris Sud. This participatory project is in the process of being implemented and relies on regular interventions by street artists to enrich a route that already has a wealth of attractions. Ernesto Novo created the first mural in Paris (64 Rue du Moulin-des-Prés, 75013) in May 2019.

STREET ART FESTIVALS

ToysOmik - Underground Effect

Helio Bray - Underground Effect

Huge - Underground Effect

IN PARIS

↘ **FestiWall** (see p. 112)

↘ **Ourcq Living Colors** (see p. 110)

↘ **Underground Effect #6**, is held thanks to the efforts of Project Saato, the festival's initiator and creator. As in previous years, the squares in the business district La Défense will temporarily be cloaked in colour. You will discover leading international street artists who will paint murals to the rhythm of music. Afterwards, the works will be exhibited in the car parks of neighbouring buildings. On projetsaato.com the new programme can be found.

IN THE BANLIEUES

↘ More than just a festival, **the Wall Street Art of Grand Paris Sud** aims to adorn the 24 municipalities of the Grand Paris Sud conglomeration with large, brightly coloured murals. James Reka, Belin, Zmogk, L7 Matrix and Jace were among the artists invited for the fifth edition in 2019.

No details have been released yet about the programme for future editions but Gautier Jourdain, the artistic director and owner of the gallery Mathgoth, promises some great collaborations.

↘ Since September 2017, Villejuif has organised the **Street Art Festival**. Initiated by graffiti artist Serty 31, the event brings together a dozen artists for live performances (graffiti, stencils, collages). See the town's website (www.villejuif.fr) for more information.

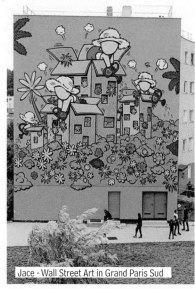
Jace - Wall Street Art in Grand Paris Sud

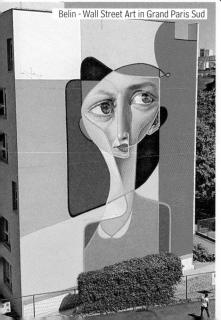
Belin - Wall Street Art in Grand Paris Sud

↘ Since 2017, the Francis-Combe de Cergy industrial estate has hosted the **Caps Attack festival**. Organised by the Art Osons collective, the event brings together local and international graffiti artists to cover the estate's walls with murals. The next festival is planned for 2021!

STREET ART FOR KIDS

Graffiti art and performances often appeal to children. Their interest is aroused by the colours and the sometimes sharp messages. Nowadays, even the youngest kids can get involved in this movement and develop their artistic sense. Here are some suggestions for introducing kids to urban art.

Let your child discover street art with these two **high-quality publications**:

↘ • a playful and educational book with plenty of references for children aged six and up
On fait le mur?, (Élan vert, €14.95) by Romain Gallisot and Sébastien Touche
• *Découvre le street art* (Albin-Michel Jeunesse, €18.90) by Caroline Desnoëttes

↘ **A puzzle** that reconstructs an impressive mural from various cities (London, Tokyo, New York). The packaging in a very realistic aerosol spray can is impressive.
• €5.90 from www.ideecadeau.fr

↘ **A graffiti book** that lets them scrawl their name on photos of various surfaces (truck trailers, walls, advertising boards etc.).
• €9.90, published by Alternatives

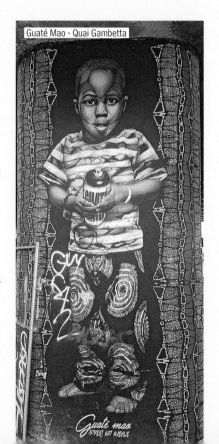

Guaté Mao - Quai Gambetta

Guaté mao
STREET ART AVENUE

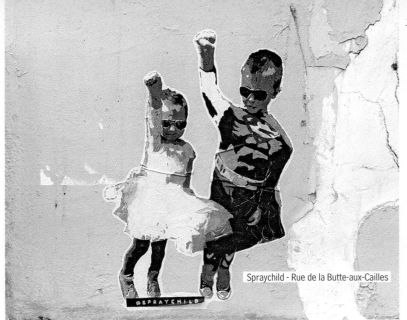

Spraychild - Rue de la Butte-aux-Cailles

↘ A giant poster they can colour in to become a true graffiti artist!
· Omy, giant poster · €15 from www.smallable.com

↘ The artist Joris offers **workshops for children aged eight and up** accompanied by an adult. The two-hour workshop introduces the kids to graffiti techniques by preparing mock-ups and then painting an actual wall (with permission)
· between €40 and €120 depending on the option chosen, see jorisdelacour.fr

↘ Fancy a **fun workshop for all the family**? The Maquis-art collective offers you this in Paris, near Beaubourg.
From age six, see www.ateliersgraffiti.fr

↘ Family walks dedicated to street art! Various routes are suggested for children, including a treasure hunt.
· For all the info, see www.familinparis.fr

Untitled (LOADING...) - RERO and Stéphane Parain - 2019

A LITTLE URBAN CULTURE

The Internet has huge numbers of websites and blogs on urban art. Here is a selection chosen for their diversity, quality, photos and content.

www.street-art-avenue.com
This site dedicated to urban art is run by two enthusiastic friends, Laurent and Jérôme. Read about the trips they made as well as artists' biographies, among other things.

billetsdemissacacia.com
This site belongs to a sparkling brunette called Cécile and it is very diverse and geared to culture. Her street art section is perfect!

www.princessepepette.com
If you want to see what it's like to hunt down street art, follow Blandine, aka Princesse Pépette.

www.streetlove.fr
Another site dedicated to urban art, where 100drine gives you all the latest info.

www.maquis-art.com
A participatory website – especially as regards photos – with loads of content.

paristonkar.net
The Internet site of the magazine Paris Tonkar, launched in 1990: an essential source!

frenchiesinparis.over-blog.com
Not just urban art, but Céline's website is definitely worth a look.

streetart360.net
A site dedicated to urban art that will tempt you to visit Bristol or Glasgow! A lot of articles on Paris too. One to follow!

urbanart-paris.fr
A blog by experts with high-quality articles, but also very involved in supporting people working in the graffiti and street art scene.

Social networks
Lots of artists mentioned in this guide present their work on social media. You're welcome to follow them!

Some indispensable books and DVDs (a personal opinion, of course):

ROA Codex, Lannoo Publishers, 2019

Street Art Today 2, Lannoo Publishers 2019, *The 50 most influential street artists today*

Carlsson B. & Louie H., **Le manuel du street art: matériel et techniques**, Flammarion, 2017 *A global survey of street art*

Gouyette C., **Sous le street art, le Louvre,** Alternatives, 2019 *When classical art inspires urban art*

Schacter R. & Fekner J., **The World Atlas of Street Art and Graffiti,** Aurum Press, 2014

Jonca F., **Jace, Magik gouzou,** Alternatives, 2017 *A cover that will take you back to your childhood and Gouzous to make you smile.*

D*Face, **The Monograph,** Albin- Michel, 2019

JR, **Unframed - Belle de Mai/ Marseille,** Alternatives, 2013 *Photos and a fab project from a city I adore*

Ben Cheikh M., **Tour Paris 13,** Albin Michel, 2014

Oak Oak, **Street Party 3**, Omaké books, 2019 *For a record of this artist's zany transformations*

Silhol B. & Oxygène N. , **Europe, street art & graffiti**, Alternatives, 2018 *The best street art sites in Europe*

Pujas S., **Street art: poésie urbaine**, Tana, 2015

Banksy, **Wall and Piece**, Century, 2006

Potter (P.), **Banksy, you are an acceptable level of threat and if you were not you would know about it**, Carpet Bombing Culture, 2019

The WALL (2010-2015): 125 Street Art Performances, Hermann, 2016

The **Opus délits** collection published by éditions Critères.

Banksy, **Exit Through the Gift Shop**, 2010 (DVD) *A gem!*

Thomas J., **Sky's the limit** (DVD) *Documentary on street art.*

INDEX OF
STREET ARTISTS

PHOTO CREDITS

Original publisher: © Editions Gallimard – Collection Alternatives - 2020

© English edition: Lannoo Publishers, Tielt, Belgium - 2020
www.lannoopublishers.com

ISBN 978 94 014 698 21
D/2020/45/291 – NUR 502/646

Translation: Clare Wilkinson, TESSERA, Wageningen, The Netherlands
Typesetting: Asterisk*, Amsterdam, The Netherlands

MIXTE
Papier issu de
sources responsables
FSC® C110418